Sporting Life

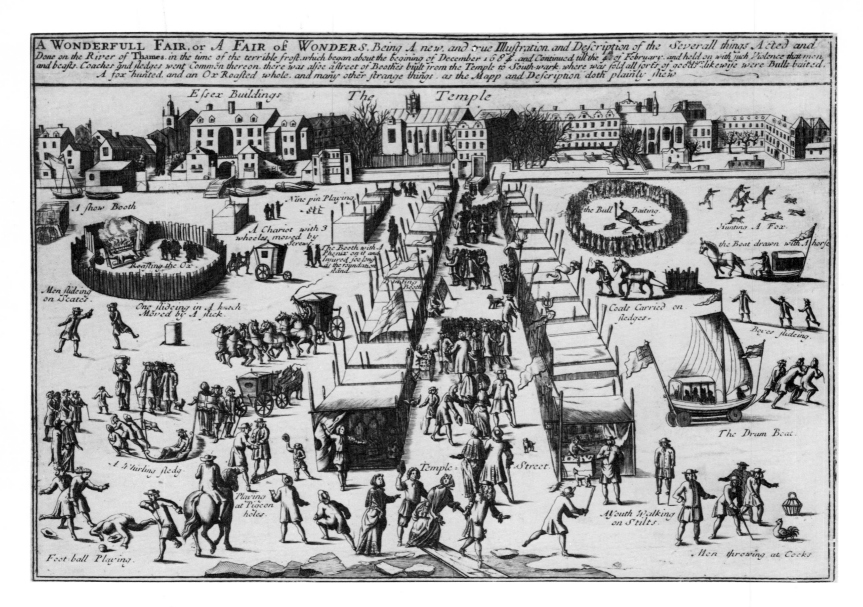

FRONTISPIECE Anonymous *The Thames Frost Fair* 1684 (no. 181b)

Sporting Life

An Anthology of British Sporting Prints

PAUL GOLDMAN

PUBLISHED FOR THE TRUSTEES OF THE BRITISH MUSEUM
BY BRITISH MUSEUM PUBLICATIONS LIMITED

© 1983 The Trustees of the British Museum

Published by British Museum Publications Ltd,
46 Bloomsbury Street, London WC1B 3QQ

British Library Cataloguing in Publication Data
Sporting life.
　1. Sporting prints, British
　I. Goldman, Paul
　769'.4'97960941　　NE960.3G/

ISBN 0-7141-0793-X

Designed by Sebastian Carter

Set in VIP Garamond
and printed in Great Britain by W. S. Cowell Ltd, Ipswich.

Contents

Acknowledgements

This exhibition has been organised by Mr Paul Goldman, Research Assistant in the Department, who has also written the catalogue. We owe a very great debt to Mr Dudley Snelgrove who has given unstintingly of his time and freely of his knowledge in advising us over the preparation of the exhibition and the compilation of the catalogue. We also wish to express our great thanks to those authorities who have so readily responded to appeals for help: Mr John Bagley, curator of Aeronautics at the Science Museum; Mr Joe Roome, Department of Water Transport, Science Museum; Mr Dennis Bird, Historian to the National Skating Association; Mr Stephen Green, curator of the Cricket Memorial Gallery, Lord's; the editors of *Golf Illustrated*, and Captain A. R. Ward, Secretary of the Royal Thames Yacht Club.

We wish to thank the Board of the British Library for so generously consenting to the loan of *Felix on the Bat* (no. 84).

Mr Reginald Williams, Senior Research Assistant in the Department, has been responsible for compiling the checklist of all the sporting prints in the Department, arranged according to Captain Frank Siltzer's classic reference work, *The Story of British Sporting Prints*, 1929.

JOHN ROWLANDS
Keeper, Department of Prints and Drawings

Introduction

'For when the One Great Scorer comes
To write against your name
He marks – not that you won or lost –
But how you played the game.'

Alumnus Football
Grantland Rice (1880–1954)

The sporting print is an almost exclusively British phenomenon. Despite frequent depictions of sports and games in European art, no country has produced so rich a legacy of prints devoted to the subject.

Prints are multiples and in their heyday those of sport fulfilled a role which today has been largely assumed by the press photograph. Both record a victory or a defeat, a comic incident or a tragic end, but unlike the click of the shutter which freezes its subject in an instant, the sporting print at its best, removed slightly from the action by a slower means of production, can imbue an event or a personality with a permanence which outlasts the transitory nature of the athletic achievement. These works move from the limited sphere of documentary evidence to a secluded corner in the annals of our art. They deserve more than a casual glance and repay serious attention because they reveal with some eloquence an important aspect of social life in Britain over three centuries. They achieve this sometimes with humour and irony, and show not only the abundant variety of the sporting scene, but also the anecdotal nature which is so important a feature of sporting life.

Sporting prints were produced in virtually unlimited numbers until the last quarter of the nineteenth century, and, unlike the paintings after which the majority were made, were often obtainable comparatively cheaply. As is frequently the case with very common objects, such prints were prized only during the brief currency of the particular event or occasion they depicted. When the immediate relevance of the subject ceased to command interest the print would fall from its owner's favour, to be replaced by another more up to date. Hence many sporting prints are now rare and the finest collections invariably belong to specialist institutions such as the Marylebone Cricket Club at Lord's and the Yale Center for British Art in the USA.

The British Museum collection of sporting prints has not

been systematically assembled, although a section devoted to 'Select Sporting Prints', containing some choice examples of the genre, has existed for many years.

This anthology has been chosen in an attempt to give a glimpse into the enthusiastic world of the British sportsman, inhabited by a number of outstanding personalities.

It is convenient to make a division between the 'true' sporting print, which may be defined as one entirely devoted to a sport, and the print where the sporting element is secondary to the main content. Into this latter category fall many of the portraits and portrait groups where the subject's identity or role is clarified by sporting equipment or dress in much the same way as a saint can be identified by his attributes. Notable examples of this type of print are *Children at Play* (The Oddie Children; no. 5) and *Richard Tattersall* (no. 124) which are both memorable as works of art in their own right. They are also fine specimens of the mezzotint skills of Thomas Park and John Jones.

It may be fashionable to dismiss sporting prints for not being entirely original works and because they are, in the main, reproductive. Indeed, the majority are interpretations and repetitions of drawings and paintings by artists who are themselves sometimes little-known. They lack, in some eyes, the spark of original genius. However, to condemn a work for being other than the carping critic would have it be is to miss entirely the point and the value of a good print. First, many sporting prints record works which have disappeared, such as Hayman's paintings made to decorate the supper boxes in Vauxhall Gardens (see nos 73 and 203). Secondly, some reveal by their very accuracy details which might be overlooked in the corners of a dark and dusty canvas. One example is no. 31 where the artist, Zoffany, includes a telling self-portrait amongst the preoccupied spectators of the cock-match. Finally, whatever some of these prints appear to lack in originality is more than compensated for by the brilliant skill of mezzotinters such as Charles Turner and Valentine Green, aquatint engravers of the calibre of Charles and George Hunt and etchers as delicate and sensitive as Francis Barlow.

Conversely, there are numerous works here which are totally original in concept and owe nothing to other models. Conspicuous examples are Barlow's *Last horse race run before Charles II* (no. 121); Hogarth's *The Cockpit* (no. 30) and Géricault's *Boxeurs* (no. 58). More recent works of complete originality are Nash's *Pony, the footballer* (no. 112), Austin's intense and moving portrait of an elderly fisherman (no. 108) and Greengrass's *Hurdlers* (no. 22), full of vorticist vivacity. When seen in this light the interest and appeal of the sporting print begins to emerge.

These prints present a panorama of an important area of British life, which reflects attitudes and beliefs held by many who never went near a racecourse or a boxing ring. The picture is by turns charming and attractive, bestial and horrifying. The gentility of the lady archers (no. 7) and the dignity of the bemedalled golfer, *Henry Callender* (no. 117) contrast strikingly with the repellent scene of bull-baiting (no. 24) or the equally disturbing *Fight between a dog and a monkey* (no. 34). The stories behind many of the prize-fight prints and those of horse-racing are frequently tragic and cruel. We know that Tom Molineaux (no. 58) died miserable and destitute at an early age, and both the horses in no. 125 were so brutally beaten that they never raced again. However, a vein of gentle humour runs through many of the anecdotes told by the prints. We can share Jem Robinson's happiest week (no. 133), feel the fun of *Foot-ball* (no. 111) and laugh at Du Maurier's gentle quips at the Victorian middle-classes (nos 47, 48, 88, 197).

Some of these prints reflect the dishonesty and corruption

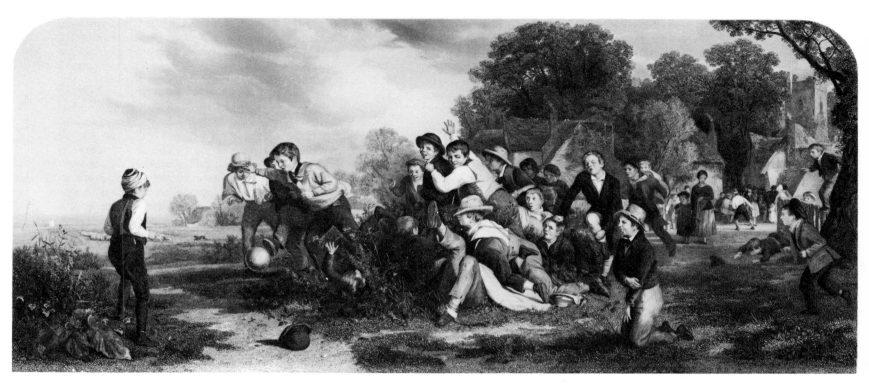

Thomas Webster *Foot-ball* 1864 (no. 111)

exemplified by the activities of the 'Ring' (see no. 129), and there are tales of enormous wagers on fights and cock-matches. Money has always played an important part in many sports, and the transfer fees paid for footballers today are merely one element in a continuously evolving process (see no. 125). Gambling and sport have invariably been closely linked, which meant that most boxers were 'professional', as were many of the early sportsmen, including some cricketers who, from the eighteenth century, were able to command large fees for their services. Even the first University Boat Race attracted heavy betting. Naturally, other sports, especially the more domestic ones such as croquet, remained truly amateur for much longer than their more popular and spectator-orientated counterparts.

In many ways it is the personalities and the anecdotes about them which make sporting prints so peculiarly memorable. The sad fate of courageous Robert Cocking (no. 40) can hardly fail to melt all but the stoniest of hearts, while the extraordinary story of the transvestite fencing champion (no. 100) and the tale of Thomas Doggett (no. 150) who founded the oldest sculling race in the world, are remarkable.

Economics and sporting prints may appear unconnected, but there seems little doubt that the multiplicity of hunting and hawking prints over those of running or football is hardly accidental. It reflects a social division: on the one side were the rich who could afford to hunt and ride and so pay fashionable artists to record them astride their steeds. The prints provided a profitable market for painter, engraver, colourist and publisher to pick up whatever they could, in extending the life of a single picture by distributing reproductions in large numbers. On the other side were the poor who might travel many miles to see a 'smock race' or a

feat of pedestrianism on their rare holidays. However, there are other reasons why some sports are more commonly represented than others, while several are conspicuous by their absence. Many sports were not officially organised with proper rules and agreed sizes of pitches until late in the nineteenth century when printmaking was making way for photography. Prints exist of certain sports not represented here since the collection lacks works showing, for example, hockey, rugby and the Eton wall-game.

The exhibition is organised alphabetically in nineteen sections, and the prints are arranged in roughly chronological order within each section. No attempt has been made to tell the history of any one sport from beginning to end, since this would be impossible with the resources available. Sports which link in some way are placed together, so wrestling conveniently joins with boxing, tennis with rackets, and athletics with gymnastics. The 'Sporting Bag', as the title suggests, contains a miscellany of sporting activities which I felt unable to amalgamate elsewhere. Among the personal discoveries made in researching the exhibition and catalogue, many fall into this section. I had been blissfully unaware, for example, of the severe traffic congestion caused in the streets of London of 1819 by the craze for velocipede riding (no. 209). Nor did I know that sand yachting took place in this country as early as 1791 (no. 207). The mass of information examined for other sections yielded further discoveries: for example, that Lunardi was not the first man in a balloon above British soil (see no. 37) and that it was a nineteenth-century trapeze artist (nos 20, 21) who gave to our language the word 'leotard'.

One drawing (no. 80) has emerged as an interesting study by Isaac Robert Cruikshank for an aquatint of the cricket ground at Darnall near Sheffield. The ground itself enjoyed a very brief popularity of less than five years.

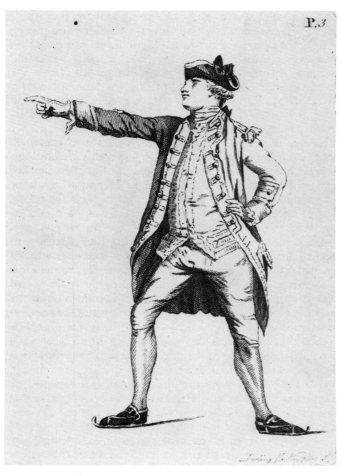

W. Darling *The Fencing Position* 1772 (no. 183)

Figure skating was a sport which I had assumed erroneously was of foreign origin. However, surprisingly, the first book on the subject was written in 1772 by a lieutenant in the Royal Artillery (see no. 183). Robert Jones is a curious and mysterious figure about whom comparatively little is known. In 1766 he published a book on fireworks and shortly after producing his historic treatise on skating was dismissed from the Royal Artillery, although the reasons for his departure have not been discovered. What is particularly notable to an observer today is the highly scientific manner in which Jones analysed skating technique, and his 'spiral line' is clearly related to the modern spiral of today.

> 'To form a large spiral line, take a run about thirty yards; and when you begin the line, throw yourself with great force on the left leg on the outside edge, the knee bent, and the body inclining forwards as much as possible; the arms must be held in the same position as an archer is described drawing his bow; the right leg raised behind as high as you can with ease.'

Sport and humour are closely allied and there are several examples which illustrate this feature. Rowlandson is merciless in his *Rural Sports or a Cricket Match Extraordinary* (no. 79)–but what is truly remarkable is the fact that the women's cricket match really took place in 1811, and is no facile invention of the artist's ever fertile mind. In contrast, the drawing of a *Prize-fight* (no. 53) is more in the spirit of his addiction to black comedy. John Leech (nos 11 and 49) shows a vein of gentle satire similar to Du Maurier's (mentioned above), while Sir Robert Frankland (no. 169) produces an imaginary type of semaphore for use in the field, and Henry Alken (no. 132) paints an entirely fictitious

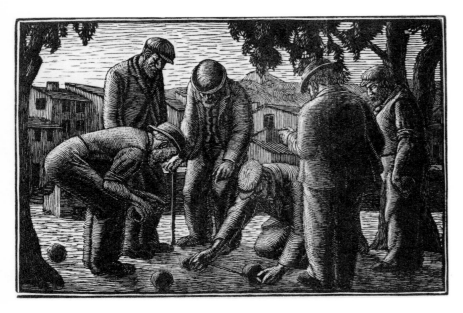

Gwendolen Raverat *Bowl Players* 1922 (no. 45)

picture purporting to be the first recorded steeplechase. To add verisimilitude to the deception, a detailed text telling of the exploits of the nightshirted riders appeared simultaneously with the prints. For many years the truth behind this fantastic invention remained unchallenged.

The exhibition features the work of an enormous variety of artists, some appearing in several sections, others confined to one or two–it is notable that 'Anonymous' has made an especially generous contribution. It is perhaps invidious to pick out individual artists from so many, but some are particularly interesting, often because they are never thought of as 'sporting artists'. For instance, it is remarkable to find G. F. Watts–'England's Michelangelo' –deigning to make drawings of cricketers (nos 81 and 82), and perhaps surprising to find Zoffany recording a cock-match (no. 31) and a little boy fishing (no. 104).

Certain foreign artists who worked in England make particularly distinguished additions to the genre of the sporting print. Horace Brodzky (no. 62) and Henri Gaudier-Brzeska (no. 66) provide highly striking and memorable images of boxing and wrestling, while Lill Tschudi (no. 215), with the colourful lino-cut, *Ice-Hockey*, clearly reveals the influence of Claude Flight with whom she studied during her brief stay in London. These three works should be seen alongside equally inspired native productions such as Walter Greaves's etching of *The Last Chelsea Regatta* (no. 155), Anthony Gross's etchings of fishing (nos 109 and 110), and Gwendolen Raverat's wood-engravings of *Boule* (nos 45 and 46).

No discussion of sporting prints can be made without considering sporting literature, which frequently formed the setting from which the print shone. One of the many interesting works of this kind is Pierce Egan's *Life in London* which was published in shilling numbers in and

after July 1821. The illustrations were by Isaac Robert and George Cruikshank (see nos 33, 34, 102). Egan, a journalist and sporting writer, produced nothing so popular as this work which can be read as a guide to the 'fast' life. To be strictly truthful there is little genuine sport in the book; it dwells mainly on the drinking, gambling and rioting enjoyed by the chief protagonists, Corinthian Tom and Jerry Hawthorn. However, the illustrations are vivid evocations of cockfighting, boxing and fencing, and they can be enjoyed in the way they were intended–to amuse and divert. Egan is by no means the first sporting writer; in literary terms he is overshadowed by classics such as Walton's *The Compleat Angler*, and the works of 'Nimrod'–Charles James Apperly. John Gibson Lockhart said of Nimrod that he could 'hunt like Hugo Meynell and write like Walter Scott'. Nimrod, unlike Egan, was an educated man, a country squire and a true sportsman. He is best known for *The Life of a Sportsman* and *Memoirs of the Life of John Mytton*, both of which were illustrated by Henry Alken. *The Life of a Sportsman*, published in 1842, is a delightful account of life in the country with valuable descriptions of hunts and four-in-hand driving (see no. 71). Soon, a more humorous sporting writer, Robert Smith Surtees appeared and published in 1838 his *Jorrocks' Jaunts and Jollities*, illustrated in colour by Alken. A number of other books featuring Mr Jorrocks followed, and the illustrators included John Leech and 'Phiz' (Hablot Knight Browne).

There are other important writers on sport who also deserve mention: William Hazlitt wrote what is arguably the finest description of a prize-fight in *The New Monthly Magazine* for February 1822. He tells how on a wet and freezing winter night he travelled to Hungerford and went without a bed in order to see 'The Gasman' (Thomas Hickman) fight Bill Neate. Hazlitt greatly admired the courage and the dedication of these pugilists and the essay clearly displays the author's real fascination and love for 'the noble art'.

Thus the link between the prints and the literature of sport is apparent. English fiction has also, of course, found a place for sport within its voluminous pages. The part played by sport in novels and in poetry is frequently a central one where the conflict of the players echoes the emotions and feelings of participants and spectators. One memorable example is the archery contest in George Eliot's *Daniel Deronda* where Gwendolen Harleth first encounters Grandcourt; another is the cricket match in L. P. Hartley's *The Go-Between*. One could also add De Selincourt's *The Cricket Match* and the hunts in the works of Siegfried Sassoon. In a totally different vein, who can forget the delectable Miss Joan Hunter Dunn in Betjeman's passionate and nostalgic hymn to 'love-all' on the tennis-court–*A Subaltern's Love song*?

Sport plays, and has played, a central rather than a peripheral role in British life. It is for this paramount reason that sporting prints warrant examination and study together with the books they illustrate. The mention of sport in literature is no mere whim, for it strengthens the argument that sport and life in Britain are inextricably interwoven. However, when all is said, the exhibition offered here is intended to show above all the pleasure, fun and sheer ebullience of our sporting life.

PAUL GOLDMAN

Notes to the Catalogue

Measurements are in millimetres, height before width.

Intaglio prints, i.e. etchings and engravings, are measured to the plate mark.

Surface prints, i.e. lithographs, are measured to the size of the sheet.

The term *colour* refers to a work printed entirely in colour.

The term *coloured* refers to a work wholly or partially coloured by hand.

The sports are arranged alphabetically in sections and chronologically within each section. Sports not mentioned in the list of contents may be found by consulting the index.

The numbers in the indexes refer to catalogue numbers.

Dates and names of artists enclosed within square brackets indicate that they are not on the print but the information has been found elsewhere. Such brackets enclosing a number I or II after a name denote the elder and the younger respectively.

Drawings are included either where they relate specifically to prints or where no suitable print was available for exhibition.

Works by foreign artists are included either because the artist was at some time resident in Britain or because the scene represented took place in this country.

Abbreviations

R.A. Royal Academician
A.R.A. Associate of the Royal Academy
A.E. Associate Engraver of the Royal Academy
P.R.S.A. President of the Royal Scottish Academy
Pub. Published

Catalogue

Archery

1

THOMAS MURRAY (MURREY) (1663–1734)

Thomas Gill

Mezzotint by John Smith (1654–1742); 240 × 190 mm; cut impression, *c.* 1694.
Son of Thomas Gill (d. 1714), a celebrated physician.
1902–10–11–4574

2

ANONYMOUS

A View of the Shooting for the Silver Arrow at Harrow the Hill (Archery scorecard), 1769

Engraving by Charles Knight (1743–1826); 240 × 260 mm.
In 1684 Sir Gilbert Talbot presented a silver arrow worth three pounds to Harrow School as a prize for shooting. The contest eventually became a regular fixture and

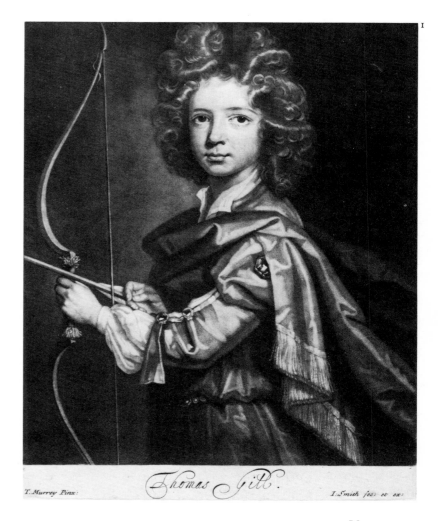

4a

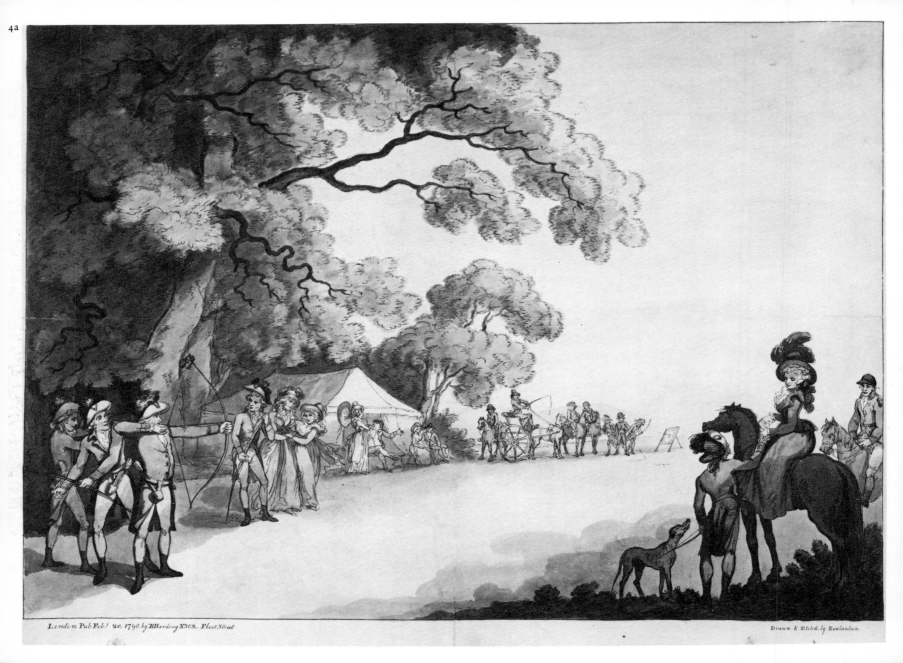

London Pub. Feb.ʸ 20. 1790. by E Harding N.º 132. Fleet Street

Drawn & Etch'd. by Rowlandson.

although interrupted by the reign of James II, lasted until 1771. A few of the silver arrows are still preserved at Harrow. The tradition lives on, at least in name, in a rifle match called the Silver Arrow Competition, and as part of the crest of the school which bears two crossed arrows.
U. 5–71

3

JOSEPH SLATER (c. 1750–1805)

Archery

Engraving by James Heath (1757–1834); 482 × 641 mm; pub. by the artist, 1789.
The bowman has been tentatively identified as Thomas Waring, who was secretary to Sir Ashton Lever, the founder of the Royal Toxophilite Society.
1873–7–12–551

4a,b

THOMAS ROWLANDSON (1756–1827)

Toxophilites (2 plates – by Gentlemen; by Ladies)

Hand-coloured etchings; 410 × 530 mm; cut impressions; pub. E. Harding, 1790.
C.2–2002, 3

5

SIR WILLIAM BEECHEY, R.A. (1753–1839)

Children at Play (The Oddie Children)

Mezzotint engraved by Thomas Park (1759–1834); 502 × 479 mm; pub. by the engraver, 1791.

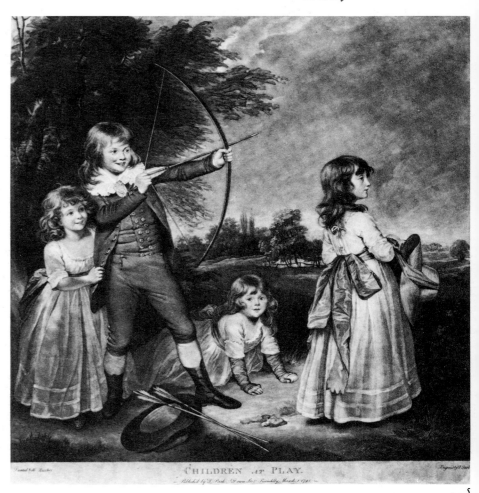

CHILDREN AT PLAY.

5

The children of Henry Hoyle Oddie, a solicitor of London and Barnwell Castle, Northamptonshire, painted in 1791.
1902–10–11–3570

6a,b

ANONYMOUS

Archery (Plates 1 and 2 – by Gentlemen; by Ladies)

Mezzotints; 352 × 248 mm; pub. Robert Sayer, 1792, nos 278, 279.
C.2–2004,5

7

JOHN EMES (*fl*.1783–d. *c*.1809) **with figures by ROBERT SMIRKE, R.A.** (1752–1845)

The Royal Society of British Archers in Gwersyllt Park, Denbighshire, 1794

Watercolours and indian ink; 425 × 595 mm.
The Society, also called the Royal Toxophilite Society, was founded by Sir Ashton Lever (1729–82) and although patronized by royalty over many years, did not receive the title 'Royal' until 1847.
1867–3–9–74 *Plate 6*

8

CORNELIS APOSTOOL (1762–1844)

Aquatint of the above drawing.
485 × 615 mm; pub. J. Emes, 1794.
1875–7–10–3691

9

SIR HENRY RAEBURN, R.A. (1756–1823)

Dr. Nathaniel Spens in the uniform of a Scottish Archer,
1791

Engraving by John Beugo (1759–1841); 680 × 455 mm;
pub. by the engraver, 1796.
Spens (1728–1815), President of the Royal College of
Physicians, Edinburgh (1794–6), was a prominent member
of the Royal Company of Archers which owns the
painting. He is seen here wearing the costume of the
Company.
1877–7–14–39

10

JOHN TOWNSHEND (*fl.* 1820–40)

Royal British Bowmen in the Grounds of Erthig,
Denbighshire, 1822

Colour aquatint by William James Bennett (1787–1844);
300 × 390 mm; pub. 1823.
The Royal British Bowmen club was formed in the late
eighteenth century and flourished, except during the
Napoleonic War, until 1880. It was the first society to
admit ladies as members.
1917–12–8–3343

11

JOHN LEECH (1817–64)

The Fair Toxophilites

Chromolithograph; 442 × 635 mm; pub. Agnew and Son, 1865.
1919–10–14–22

12

GEORGE ELGAR HICKS (1824–1914)

Archery – Loosing

Stipple and mezzotint by Charles Algernon Tomkins (1821–1905); 365 × 410 mm; pub. Lloyd Bros, 1867.
One of a set of three of archery. The other two, *Bracing* and *Knocking*, are also in the collection.
Hicks mentions the original oil sketches which he made of these subjects in his notebook of 1863:

> 'Three Archery studies 24 × 18 inches
> Stringing
> Knocking
> Loosing
> Sold to Mr Wallis with copyright £35 each.'

(I am grateful to Rosamond Allwood of the Geffrye Museum for providing this information.)
1875–4–10–449

Athletics and Gymnastics

13

ANONYMOUS

'Captain' Robert Dover: Cotswold Games

Engraving; 164 × 117 mm; copy from a woodcut prefixed to the rare tract *Annalia Dubrensia*, 1636. Plate to Caulfield's *Remarkable Persons*, 1794.
Dover (1575–1641) instituted the games, said to be the forerunners of the modern Olympics, in about 1612. The games consisted of football, skittles, quoits, shovelboard, chess, cudgel and single stick bouts, bull-baiting, cockfighting, bowls, wrestling, shin-kicking, dancing, racing both on foot and horseback, throwing the hammer and hare coursing. The games continued until 1852, apart from a short break in 1644 when they were banned by the Commonwealth. They were revived on a small scale after the Second World War and continue to take place on the Friday evening of Whit Week on Dover's Hill, Chipping Campden, Gloucestershire.
1983.U.2069

14

JOHN COLLET (c.1725–80)

A Women's Smock Race

Engraving; 254 × 366 mm; pub. 1770.
Running races for prizes such as a 'Holland Smock' took place frequently at country fairs. The notice on the tree

COTSWOLD GAMES.

announces a sack race for men – the prize being a flitch of bacon. The two hats hanging from the tree with the smock are also prizes.
1878–7–13–1319

15

THOMAS ROWLANDSON (1756–1827)

A Smock Race at a Country Fair

Pen, indian ink and wash; watercolours; 241 × 376 mm. Signed.
1876–7–8–8

16

? THOMAS LORD BUSBY (*fl*. 1804–21)

Lieutenant Fairman in the act of Running

Aquatint; 226 × 167 mm
1851–3–8–256

17

-- WILLIAMS (*fl*. 1809–15)

Captain Robert Barclay Allardice (known as Captain Barclay)

Colour aquatint; 420× 295 mm; pub. S. W. Fores, 1809. Barclay (1779–1854) is seen on Newmarket Heath performing his feat of walking a thousand miles in a thousand hours for a wager of one thousand guineas. Pedestrianism had a popular following, and contests,

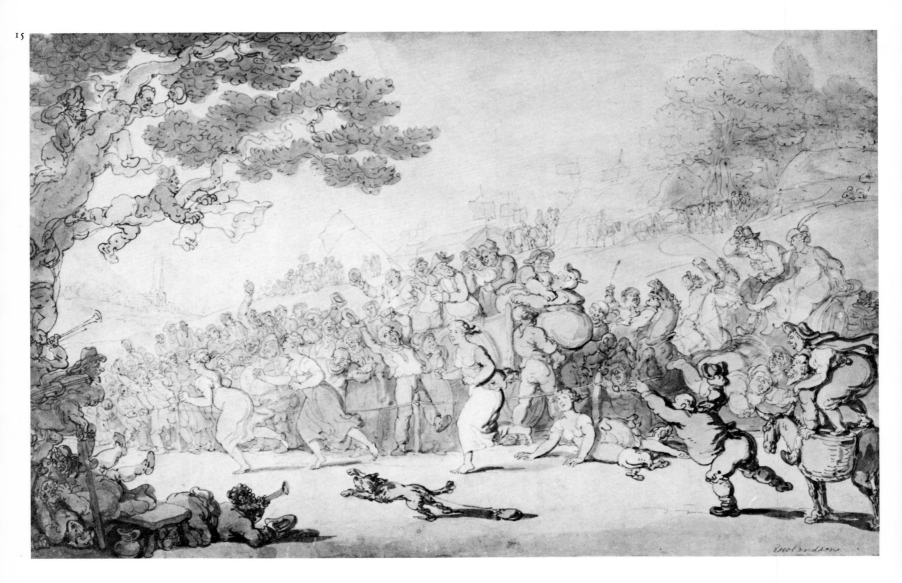

16

To the Amateurs of athletic Sports & Exercises, this Representation of
LIEU⸑ FAIRMAN,
taken on the Ground, in the Act of Running, is Respectfully dedicated by T. Busby.

sometimes for large wagers, attracted many spectators. Barclay was also the first scientific trainer to recognise the value of road work for boxers. Tom Cribb was one of the most celebrated to benefit from this training.
1857–3–8–99

18

-- WILLIAMS (*fl*.1809–15)

George Wilson the Pedestrian

Hand-coloured etching; 274 × 189 mm; pub. T. Palser, 1815.
Wilson (b.1765) here aged fifty, on the twelfth day of his feat of walking one thousand miles in twenty days.
1857–3–8–720

19

W. THOMSON (*fl*. 1828–42)

'Temperance' – a Pedestrian

Lithograph; 494 × 370 mm; pub. E. T. Drinkwater, 1842.
As he appeared in a walking match between Colnbrook and Hounslow on 4 May 1841. The inscription records that 'Temperance' was also a runner.
1980.U.1086

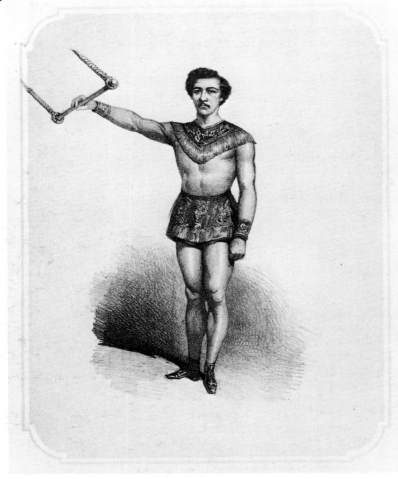

20

ANONYMOUS

Léotard – Gymnast

Lithograph; 245 × 192 mm; *c.* 1860.
Jules Léotard, a Frenchman (1830–70) first trained as a lawyer, and invented the flying trapeze in 1859. When he first performed in London at the Old Alhambra, Leicester Square, he received £180 per week to fly through the air with no net beneath him. He was the subject of the Music-hall song, 'The Daring Young Man on the Flying Trapeze', and the tight-fitting garment which he wore has passed his name into our gymnastic language.
1865–1–14–435

21a,b

ANONYMOUS

Léotard – Gymnast

Lithographs (2); 116 × 60 mm; *c.* 1860.
As he appeared at Cremorne Gardens.
1901–10–22–1644,5

22

WILLIAM EDWARD GREENGRASS
(1896–1970)

'Hurdlers'

Colour lino-cut; 232 × 278 mm; signed and dated 1932.
1934–12–8–110

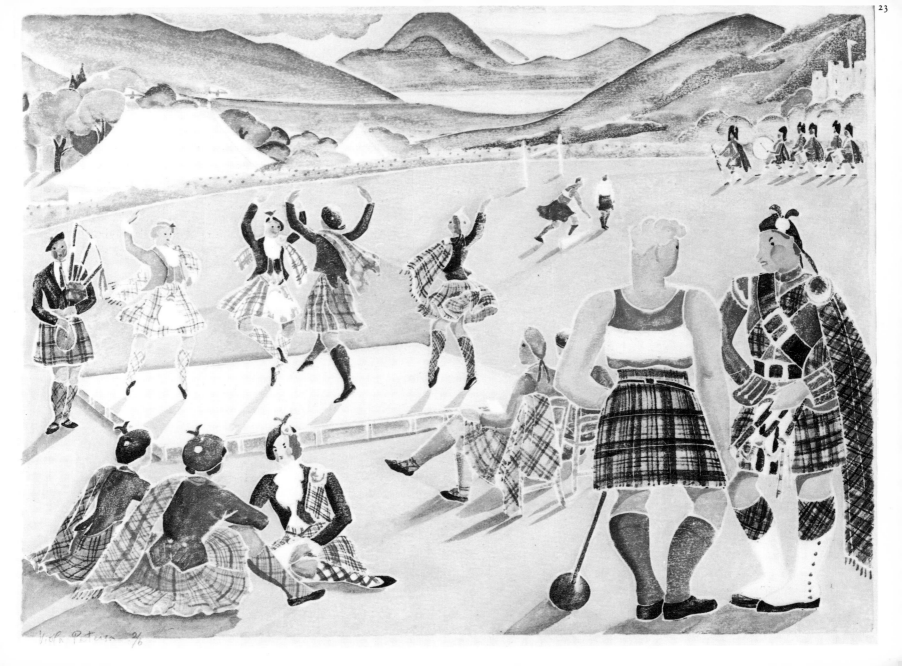

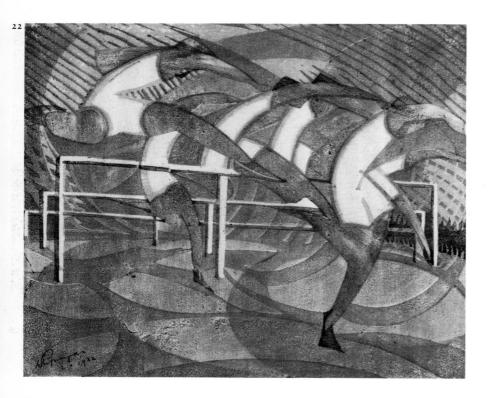

23

MARY VIOLA PATERSON (b. 1899)

The Highland Games

Colour woodcut; 242 × 320 mm; *c.* 1935 ?
From an edition of only six prints.
1937–7–10–91

Animal Baiting and Fighting

ANIMAL BAITING

24

ANONYMOUS

The Bull Bait

Engraving; 349 × 447 mm; *c.* 1775.
Bull-baiting and bear-baiting, which John Evelyn called in
1670 'A rude and dirty pastime', were not forbidden by law
until 1835. Even after this prohibition baits were organised
in secret. A bull-bait was reported to have taken place as
late as 1853, in West Derby, now part of Liverpool but
then a village outside the city.
1870–10–8–1332

25

ANONYMOUS

The Bull Bait

Mezzotint by William Say (1768–1834); 563 × 782 mm;
c. 1790(?).
Bulldogs, used in bull-baiting because of their tenacity and
the grip of their teeth, were trained to fasten their bite on
the bull's nose, which was known as 'pinning the bull'.
1852-10-9-1174

26

HENRY ALKEN (1785–1851)

A Bear Bait at Charley's Theatre Westminster

Hand-coloured aquatint; 119 × 178 mm.
1862-10-11-510

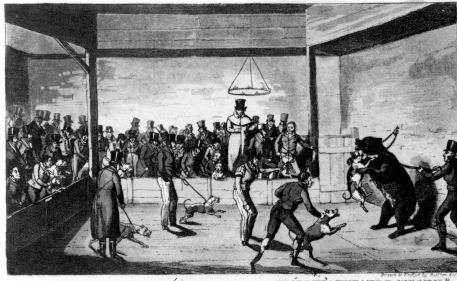

THE COUNTRY SQUIRE *taking a peep at* CHARLEY'S THEATRE WESTM^R.
where the Performers are of the Old School.

26

THE RAT PIT

27

ANONYMOUS

Broadsheet advertising the Westminster Rat Pit

341 × 204 mm; 1 March 1825.
1862-10-11-529

28

THEODORE LANE (1800–28)

The Celebrated Dog BILLY killing 100 Rats at the Westminster Pit

Hand-coloured etching and aquatint; 142 × 225 mm; pub. Knight and Lacey, 1825.
Dogs were backed to kill a given number of rats within a set time, the dogs being weighed, since weight in relation to performance was crucial, and timed by a stop watch. The sport is said to persist today in the Black Country.
1862–10–11–537

29

ANONYMOUS

BILLY . . . killing 100 Rats in five minutes and a half

Aquatint; 224 × 269 mm; pub. S. Knights, *c.* 1825.
1862–10–11–538

COCKFIGHTING

30

WILLIAM HOGARTH (1697–1764)

The Cockpit

Etching and engraving; 316 × 396 mm; pub. 1759.
The scene represented is a cockfight in the Royal Cockpit

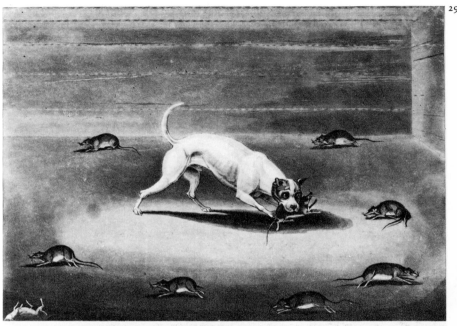

BILLY,
THE UNRIVALLED DOG PERFORMING HIS WONDERFUL MATCH OF KILLING 100 RATS IN FIVE MINUTES AND A HALF.

Published by S. Knights, 3, Sweeting Alley, Royal Exchange,
where may be had a larger Print representing the Interior of the Westminster Pit with Portraits.

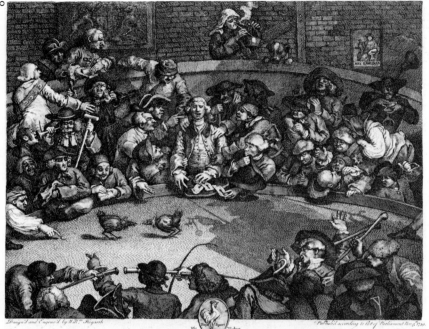

in Birdcage Walk, which was built by Henry VIII and finally closed in 1816. Cockfighting was the most popular sport of all classes at the time. It was made illegal in 1849 but went on secretly for many years and prosecutions even in recent times are not unknown. Colloquial phrases such as 'pit against' and 'cut out for' are derived from cockfighting.
1868–8–22–1618

31
JOHANN ZOFFANY, R.A. (1733–1810)

Colonel Mordaunt's Cock Match. At Lucknow . . . in 1786

Mezzotint by Richard Earlom (1743–1822); 530 × 681 mm; pub. R. Sayer, 1792.
The contest is between the game-cocks of Colonel Mordaunt and the Nawab Wazir of Oudh, Asaf-ud-daula, who are seen facing one another with outstretched arms. The painting was done for Warren Hastings and Zoffany himself is seated on the far right, holding a pencil.
1872–3–9–428

32
BENJAMIN MARSHALL (1767–1835)

The Trimm'd Cock

Mixed method by Charles Turner, A. E. (1773–1857); 530 × 400 mm; pub. by the engraver, 1812.
A pair to *Cock in Feather*. The cock is shown ready for battle and wearing its sharp spurs. The painting was exhibited at the Royal Academy in 1812 (no. 703).
1891–4–14–424

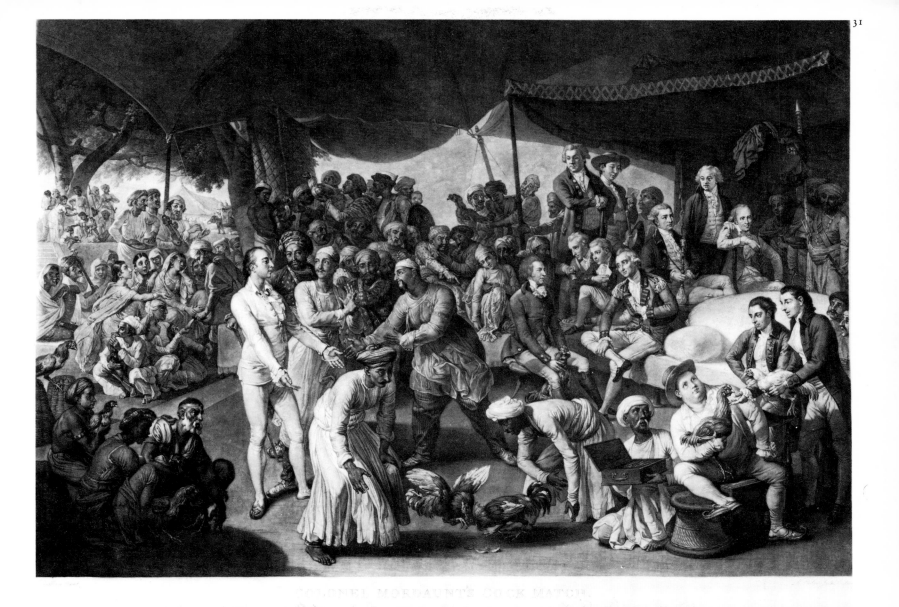

COLONEL MORDAUNT'S COCK MATCH

33

ISAAC ROBERT CRUIKSHANK (1789–1856)
and GEORGE CRUIKSHANK (1792–1878)

At The Royal Cockpit

Hand-coloured aquatint; 132 × 212 mm; plate to Pierce
Egan's *Life in London*, 1821, facing p. 318.
1935–9–16–5

DOGFIGHTING

34

ISAAC ROBERT CRUIKSHANK (1789–1856)
and GEORGE CRUIKSHANK (1792–1878)

*A Fight between a dog and a monkey at the Westminster
Pit.*

Hand-coloured aquatint; 132 × 212 mm; plate to Pierce
Egan's *Life in London*, 1821, facing p. 225.
1935–9–16–4

35

ISAAC ROBERT CRUIKSHANK (1789–1856)

The Westminster Pit

Hand-coloured aquatint; 109 × 139 mm; *c.* 1820.
Dogfighting, involving highly trained and healthy dogs,
called for skill and patience from owners. As cockfighting

declined, this cruel sport flourished mainly in public houses and is vividly described in Mayhew's *London* (1870).
1862–10–11–536

Ballooning

36
ANONYMOUS

Centre: *The ascent of Mess^{rs} Charles and Roberts Balloon,* 1783
Left: *Biaggini's Air Balloon*
Right: *The Fall of the Balloon*

Hand-coloured etching, fan mounted on bone; 1783. Jacques Alexandre Cesar Charles (1746–1823) and one of the brothers Robert ascended from the Tuileries, Paris, on 1 December 1783. It was the first ascent by hydrogen balloon and the second to contain human passengers. Michael Biaggini, an Italian maker of artificial flowers resident in London, assisted Francesco Zambecarri (1756–1812), whose unmanned balloon ascended from Biaggini's garden in Cheapside on 4 November 1783.
1891–7–13–124

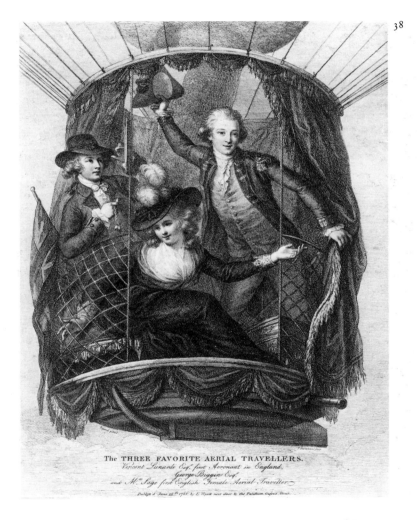

The THREE FAVORITE AERIAL TRAVELLERS.
Vincent Lunardi Esq.^r first Aeronaut in England.
George Biggin Esq.^r
and M.^{rs} Sage first English Female Aerial Traveller.

Publish.d June 28.th 1785 by E. Wyatt next door to the Pantheon Oxford Street.

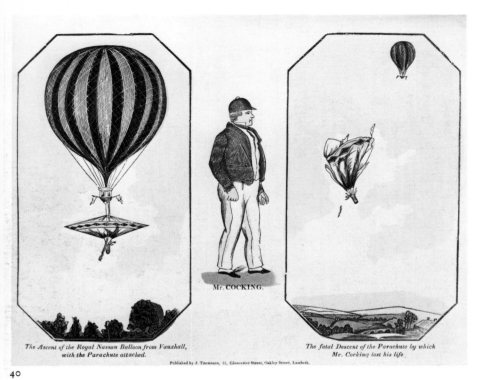

The Ascent of the Royal Nassau Balloon from Vauxhall,
with the Parachute attached.

Mr. COCKING.

The fatal Descent of the Parachute by which
Mr. Cocking lost his life.

Published by J. Thompson, 21, Gloucester Street, Oakley Street, Lambeth.

40

37

JOHN JAMES BREWER (*fl.* 1779/80)

Lunardi's ascent from the Artillery ground Moorfields. Sept 15th 1784

Hand-coloured etching; 375 × 515 mm; 1784.
Vincenzo Lunardi (1759–1806) ascended in a hydrogen balloon from the Honourable Artillery Company's ground at Moorfields on 15 September 1784, in the presence of nearly 200,000 spectators. Lunardi was not the first man to rise in a balloon above British soil, as on 27 August 1784 James Tytler had made a brief ascent from Comely Gardens, Edinburgh.
1899–4–20–103 *Plate 2*

38

JEAN FRANÇOIS RIGAUD, R.A. (1742–1810)

The Three Favorite Aerial Travellers (Vincenzo Lunardi, Mrs Sage, George Biggin)

Stipple engraving by Francesco Bartolozzi, R.A. (1727–1815); 334 × 250 mm; pub. E. Wyatt, 1785.
Lunardi (1759–1806), known as the 'first aerial traveller in the English atmosphere', had arranged to take up Mrs Letitia Anne Sage, a famous beauty, and George Biggin, from St George's Fields on 29 June 1785. However, the balloon proved incapable of lifting more than two people so Biggin and Mrs Sage ascended alone. Needless to say, the print shows Lunardi also on board. The painting by Rigaud is in the Yale Center for British Art, New Haven, U.S.A.
1870–5–14–1409

39

W. GAUCI (*fl.* 1826/7–1854)

Balloon Ascent of P. Cornillot on Aug 23rd 1825

Lithograph; 395 × 445 mm; pub. M. Colnaghi, 1826.
Cornillot attempted to steer his balloon horizontally.
1871–8–12–5318

40

ANONYMOUS

Robert Cocking, Balloonist

Hand-coloured woodcut; 250 × 320 mm; pub.
J. Thompson, 1837.
Cocking was suspended below a balloon piloted by Charles
Green, in a special form of parachute which collapsed as
soon as it was released, tragically causing Cocking to fall to
his death on 24 July 1837.
1914–11–17–48

41

ROBERT BLEMME SCHNEBBELIE
(d. *c.* 1849)

*Mr Graham's Balloon at Lord's Cricket Ground, 12th Sept.
1837*

Watercolours; 153 × 193 mm; signed and dated 1839.
George Graham and his wife Margaret made numerous
ascents between 1823 and 1852.
1879–8–9–652

41

Bowls and Croquet

BOWLS

42

SIR JAMES THORNHILL (1675/6–1734)

Hanbury Hall (Worcs) from the Bowling Green

Pen and brown ink with grey wash over pencil; 283 × 443 mm; *c.* 1710.
The house, containing a ceiling painted by Thornhill, was owned by Thomas Vernon, an eminent lawyer.
1864–5–14–272

43

WILLIAM KENT (1685–1748)

Bowls at Stowe House, Bucks

Pen, ink and brown wash; 304 × 474 mm; *c.* 1735(?).
In the background is the Temple of Ancient Virtue, designed by Kent for Lord Cobham in the 1730s, which still stands.
1962–7–14–49

44

SIR GEORGE HARVEY, P.R.S.A. (1806–76)

The Bowlers

Engraving by William Henry Simmons (1811–82); 387 × 749 mm; (cut impression); pub. E. Gambart and Co., 1852.
The painting, dated 1850, does not illustrate any particular match. It was exhibited at the Royal Academy in 1850 (no. 452) and is now in the National Gallery of Scotland, Edinburgh.
1933–5–13–1

45

GWENDOLEN RAVERAT (1885–1957)

Bowl Players

Wood-engraving; 103 × 154 mm; signed; 1922.
The game is *boule* – the French version of bowls.
1923–12–4–9

46

GWENDOLEN RAVERAT (1885–1957)

Jeu de Boules, Vence

Wood-engraving; 103 × 152 mm; signed; 1922.
1923–12–4–20

CROQUET

47

GEORGE DU MAURIER (1834–96)

Our Croquet Party

Wood-engraving by Horace Harral (*fl.* 1860s); 214 × 142 mm; illustration to *London Society*, June 1864.
1922–4–10–62

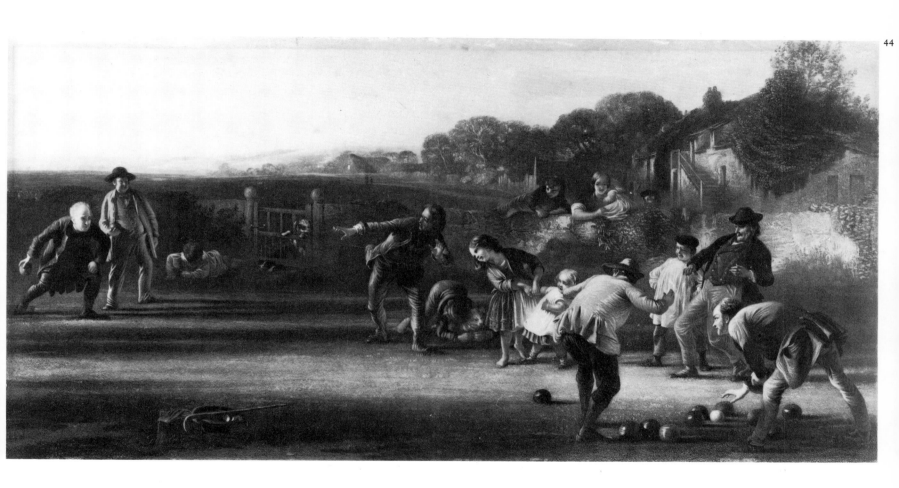

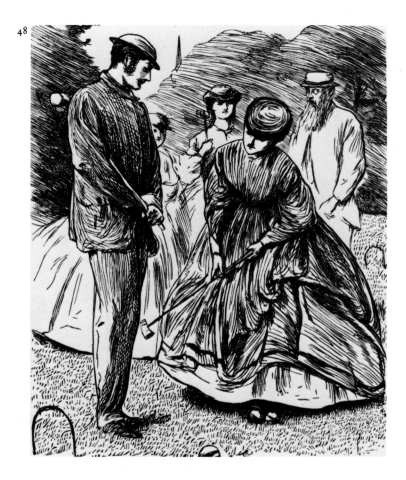
48

48

GEORGE DU MAURIER (1834–96)

How not to play the Game

Wood-engraving; 217 × 140 mm; illustration to *London Society*, July 1865.
1922–4–10–72

49

JOHN LEECH (1817–64)

A nice game for two or more

Chromolithograph; 427 × 605 mm; pub. Agnew and Son, 1865.
1952–5–15–3

Boxing and Wrestling

BOXING

50

ANONYMOUS

John Smith alias 'Buckhorse'

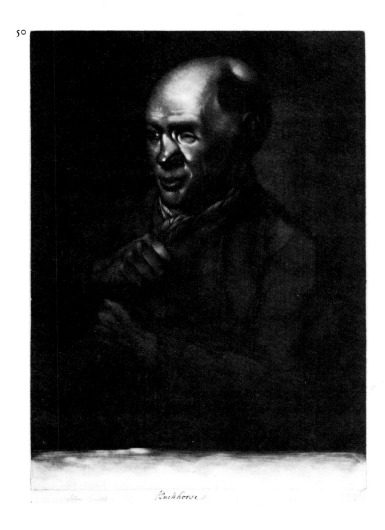

50

Buckhorse

Mezzotint; 353 × 251 mm; *c.* 1760 (?).
Dubbed 'Buckhorse', probably from the time he was riding for the Duke of Queensberry. His ugly features were further disfigured in prize-fights. He ranked high among the boxers of his day and is said to have been brought up as a thief.
1851–3–8–639

51

Attributed to
JOHN HAMILTON MORTIMER, A.R.A.
(1741–79)

The SET-TO – (left) *John Broughton and George Stevenson, c.* 1775(?)

Mezzotint by John Young (1755–1825); 597 × 813 mm (cut impression).
John, also called Jack Broughton (1705–89), and known as the 'Father of British Boxing', formulated the first code of boxing and invented the boxing glove, which at the time was used only in sparring exhibitions. He introduced into the sport stopping and blocking, hitting and retreating. Broughton's Rules governed boxing from 18 August 1743 until 1838, when a new code, 'The London Prize Ring Rules', was adopted. In this particular fight, on 24 April 1741, Broughton defeated Stevenson, known as 'The Coachman', after forty-five gruelling minutes. Stevenson died a month later from his injuries and, largely as a result, Broughton turned his attention to devising his 'Rules'.
1870–10–8–2828

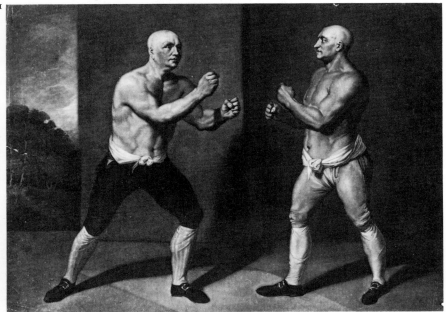

52
JOHN HOPPNER, R.A. (1758–1810)
Richard Humphreys (d. after 1790)

Mezzotint by John Young (1755–1825); 581 × 430 mm
(cut impression); pub. by the artist and engraver, 1788.
Known as 'The Gentleman Fighter', Humphreys defeated
Mendoza (see no. 54) in 1787 and 1788. After losing twice
to Mendoza he retired in September 1790.
1851–3–8–732

53
THOMAS ROWLANDSON (1756–1827)
A Prize Fight

Pen and ink and Indian ink wash; 100 × 310 mm;
c. 1785–90
1856–7–12–937

54
CHARLES JEAN ROBINEAU (*fl.* 1789)
Daniel Mendoza – The Most Scientific Boxer ever known

Mezzotint by Henry Kingsbury (*fl.* 1775–98); 579 × 429 mm;
pub. S. W. Fores, 1789.
Mendoza (1763–1836) was the first prominent Jewish
boxer and sixteenth champion of England, reigning from
1791 until 1795. He developed and cultivated ring science
and perfected a system of guarding, side-stepping and an
effective use of the straight left, and he revolutionized
boxing by demonstrating that science could defeat the
simple slogger. He was nicknamed 'The Star in the East'.
1862–5–17–183

55
ANONYMOUS
John Jackson (1769–1845)

Engraving; 335 × 227 mm; c. 1790–1800.
John 'Gentleman' Jackson was one of the greatest of the
early heavyweights. He was the first to show that a blow
was not effective unless distance had been properly judged,

52

54

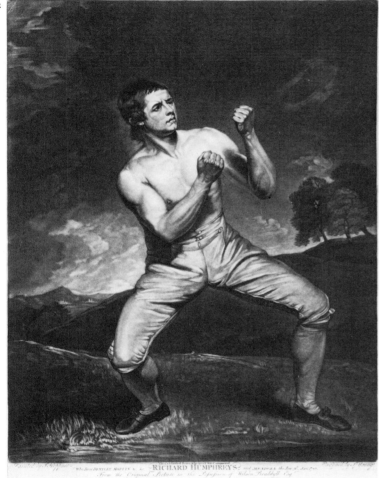

RICHARD HUMPHREYS

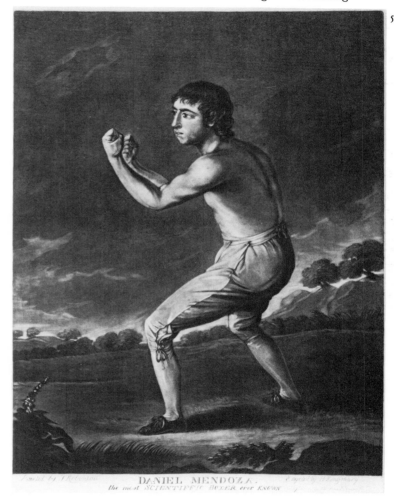

DANIEL MENDOZA
the most SCIENTIFIC BOXER ever known

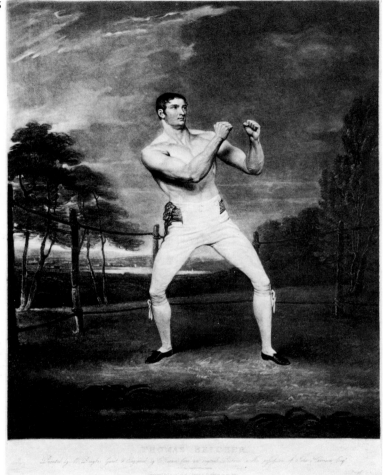

56

and was also noted for giving considerable attention to footwork. Byron was a great admirer of Jackson and called him the 'Emperor of Pugilism'.
1851–3–8–368

56

THOMAS DOUGLAS GUEST
(1781 – after 1839)

Thomas Belcher (1783–1854)

Mezzotint by Charles Turner, A. E. (1774–1857);
610 × 455 mm; pub. by the boxer, 1811.
After winning many fights, Belcher was defeated by
Samuel Elias ('Dutch Sam') and retired to keep the Castle
Tavern, Holborn.
1851–3–8–739

57

[GEORGE SHARPLES] (*c.* 1787–1849?)

Harry Harmer (1784–1834)

Mezzotint by Charles Turner, A. E. (1774–1857);
243 × 203 mm; pub. by the sitter, 1817.
The gloves he is holding were only used in sparring exhibitions.
1875–6–12–362

58

JEAN LOUIS ANDRÉ THEODORE GÉRICAULT (1791–1824)

Boxeurs

Lithograph: 352 × 416 mm; datable between 1817 and 1819.

An international bout for the heavyweight title took place between Tom Cribb (1781–1848) and Tom Molineaux (1784–1818), a negro champion from Virginia, on 18 December 1810 at Copthall Common. It was the first contest between a negro and a white man for the heavyweight championship. Cribb won in thirty-three rounds.

1876–11–11–280

59

T. BLAKE (*fl.* 1821)

The Interior of the Fives Court with Randall and Turner Sparring

Aquatint by Charles Turner, A. E. (1774–1857); 533 × 699 mm; pub. by the engraver, 1821.

Jack Randall (1794–1828) seen sparring with Ned Turner (1791–1826). Randall, called 'Nonpareil' and the 'Prime Irish Lad', was the most accomplished middleweight in England at this time and won all fifteen bouts of his career (1815–21) by knockouts. The Fives Court was in James St, Haymarket. The boxers are wearing gloves as was usual in these exhibitions. Many famous boxers in the audience are identified by a key (of which an impression is in the collection).

1891–4–14–393

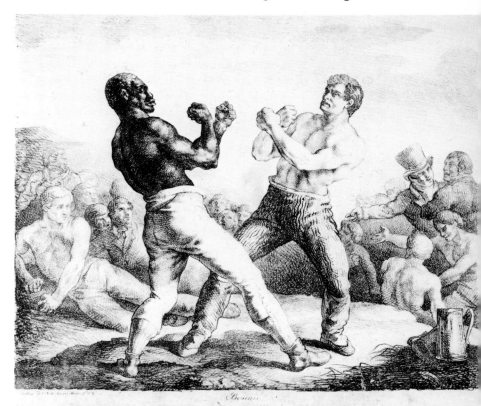

58

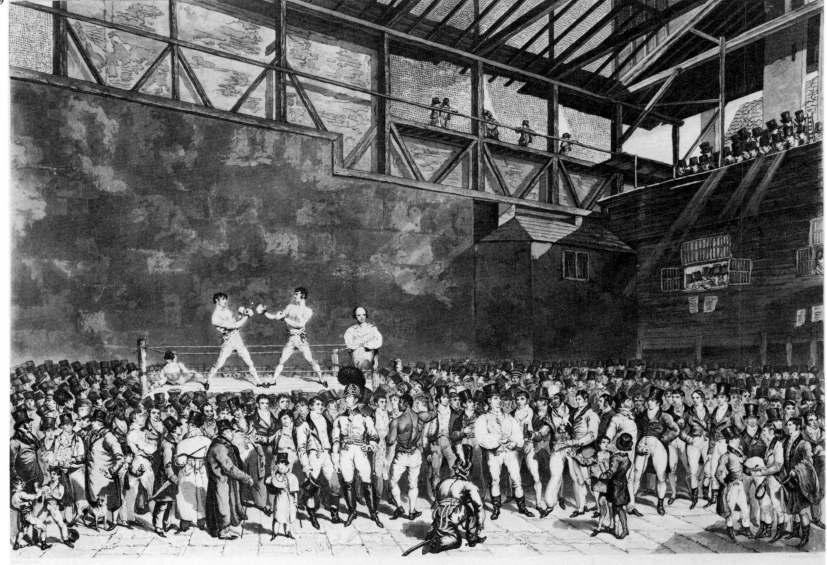

THE INTERIOR OF THE FIVE'S COURT,
With RANDALL and TURNER Sparring

60

JOHN JACKSON, R.A. (1778–1831)

Tom Cribb (1781–1848)

Hand-coloured aquatint by George Hunt (*fl.* 1820–1840); 386 × 304 mm; (cut impression); pub. J. Moore, 1842. Known as 'The Black Diamond', Cribb was perhaps the most celebrated of heavyweight champions and reigned supreme from 1809 to 1822. George Borrow said that he was 'Champion of England, and perhaps the best man in England'.
1949–4–11–5266

61

GEORGE FREDERICK ARTHUR BELCHER, R.A. (1875–1947)

Pat O'Keeffe – The Wild Irishman

Hand-coloured etching; 340 × 235 mm; 1918. An outstanding middleweight of the 1920s.
1920–11–23–10

62

HORACE BRODZKY (1885–1969)

Boxers

Lino-cut; 253 × 184 mm; 1919.
1924–1–8–5(15) 248.a.25

63

SIR FRANK BRANGWYN, R.A. (1867–1956)

Boxers

Woodcut; 151 × 210 mm.
1943–12–11–431

WRESTLING

64

Unknown artist with initials H. B. (*fl.* 1820)

Abraham Cann, Wrestling Champion of England (*fl.* 1820)

Lithograph; 423 × 293 mm (cut impression).
1868–6–12–1077

65

ANONYMOUS

James Polkinhorn – The Famous Cornish Wrestler

Lithograph by M. Gauci (*fl.* 1810–46); 450 × 271 mm (cut impression).
As seen in the ring at Devonport on 23 October 1826.
1943–4–10–2111

66

HENRI GAUDIER-BRZESKA (1891–1915)

Wrestlers

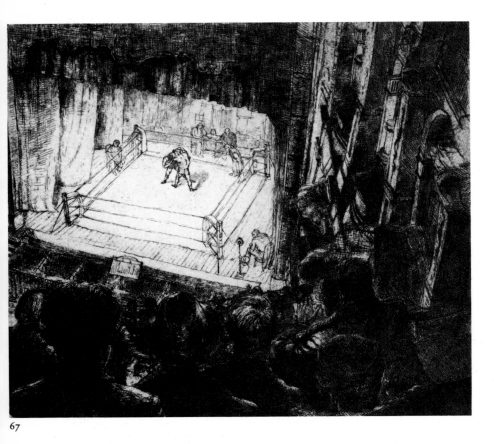

67

Lino-cut; 226 × 279 mm; 1913(?); printed by the artist's close friend Brodzky (see no. 62).
In December 1912 Gaudier saw a wrestling match in London. He wrote: 'They fought with amazing vivacity and spirit, turning in the air, falling back on their heads, and in a flash were up again on the other side, utterly incomprehensible' (H. S. Ede, *Savage Messiah*, 1931, p. 217).
1935–2–26–1

67

DAPHNE L. M. LINDNER (b.1912)

All-In Wrestling

Etching; 196 × 219 mm; signed and dated 1936.
1938–5–14–35

Coaching and Trotting

COACHING

68

JAMES POLLARD (1792–1867)

A View on the Highgate Road

Hand-coloured aquatint by George Hunt (*fl.* 1820–40); 443 × 563 mm; pub. J. Moore, 1830–7.

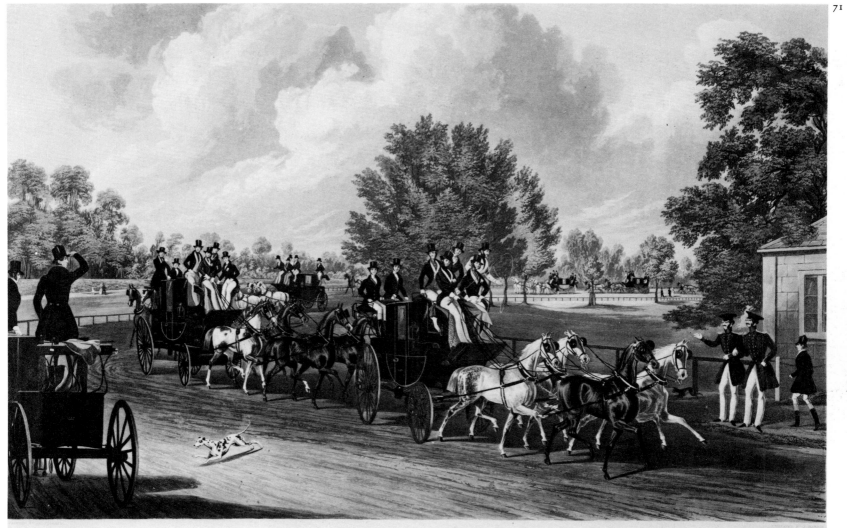

THE FOUR-IN-HAND CLUB, HYDE PARK.

Respectfully dedicated to its distinguished Members by Chas. Cuttledene

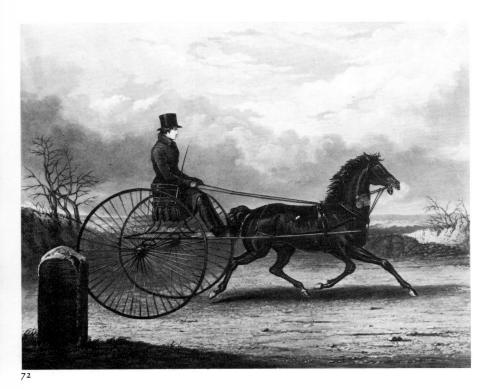

72

The coach passing the 'Woodman' is the *Independent Tally-Ho*. On May Day 1830 this coach covered the 109 miles to Birmingham in 7½ hours, beating all coaching records for sustained speed, averaging 14½ m.p.h.
1936–6–26–1

69

JAMES POLLARD (1792–1867)

West Country Mails at the Gloucester Coffee House, Piccadilly

Hand-coloured aquatint by Charles Rosenberg [11] (*fl.* 1828–48); 565 × 765 mm; pub. T. McLean, 1828.
Crace – 1880–11–13–2035

70

JAMES POLLARD (1792–1867)

The Royal Mails at the Angel Inn, Islington /on the night of His Majesty's Birthday.

Hand-coloured aquatint by Richard Gilson Reeve (1803–89); 595 × 765 mm (cut impression);
pub. T. McLean, 1828 (?).
The King's birthday was celebrated annually by a procession of Royal Mail coaches through the main streets of the West End. Twenty-eight freshly painted and gilded mails left from Lincoln's Inn Fields to St James's Palace where the King appeared. The coachmen drank the King's health, proposed by the coachman of the Bristol Mail, as senior mail of the organisation.
Crace – 1880–11–13–4908

71

JAMES POLLARD (1792–1867)

The Four-in-hand Club – Hyde Park

Hand-coloured aquatint by John Harris (1811–65);
400 × 560 mm; pub. R. Ackermann, 1838.
In 1838 Lord Chesterfield founded the Richmond Driving Club, and here the members are driving past the Magazine to dine at the Castle Hotel, Richmond. Coaching Clubs were a resort of the wealthy whose coaches were 'as elegant as private carriages and lighter even than the mails'. The painting is in the possession of the Royal Horse Guards.
Crace – 1880–11–13–1894

TROTTING

72

E. F. LAMBERT (*fl.* 1828–46)

Celebrated American Trotting Horse, Tom Thumb

Hand-coloured aquatint by George Hunt (*fl.* 1820–40) and Charles Hunt (1806 – after 1870); 358 × 455 mm;
pub. J. Moore, 1829.
Owned by George Osbaldeston (1787–1866), described by Pierce Egan in 1832 as 'a complete portrait of the thoroughbred sportsman'. He once drove this horse one hundred miles in ten hours.
1949–4–11–5264

Cricket

73

FRANCIS HAYMAN, R.A. (1708–76)

Cricket (as played at the Artillery Ground, Finsbury)

Etching and engraving by Antoine Benoist (1721–70);
290 × 361 mm; pub. 1743.
After a lost painting which was one of a set of twelve sporting subjects designed to decorate the supper boxes in Vauxhall Gardens. The match is single wicket, and by tradition the wicket-keeper is Hayman's friend, Hogarth. In 1744 the ground was the scene of a famous match between Kent and All-England, the earliest first class match of which the full score is preserved. It was on this occasion that the proprietor of the ground, George Smith, first imposed an admission charge of sixpence for watching cricket. A reduced copy of the painting, not by Hayman, is at Lord's.
1862–10–11–615

74

ANONYMOUS

Cricket match in front of a Church Tower

Bodycolours; 132 × 187 mm; datable *c.* 1765.
1939–7–26–23

F. Hayman Pinx! Publish'd according to Act of Parliam! April 4th 1743.

Benoist Sculp! after the Painting in Vaux-hall Garden.

CRICKET.

To exercise their Limbs, and try their Art.
Forth to the verdant Fields the Swains depart:
The buxom Air and chearfull Sport unite
To make Hulse useless by their rough Delight.

Britons, whom Nature has for War design'd,
In the soft Charms of Ease no Joy can find:
Averse to wast in Rest th'inviting Day
Toil forms their Game, & Labour is their Play.

Printed & sold by Tho. Bowles in St. Pauls Church Yard & Jn! Bowles at ye Black Horse in Cornhill.

75

JOHN COLLET (*c.* 1725–80)

Miss Wicket and Miss Trigger

Mezzotint; 152 × 114 mm; pub. 1778 (originally published in a larger version, *c.* 1770).
1876–6–8–2754

76

ROBERT DIGHTON (1752–1814)

CRICKET. Played by the Gentlemen's Club, White Conduit House. 1784

Etching and aquatint by an unknown engraver;
182 × 225 mm.
The club at White Conduit, Islington, was the parent of the M.C.C., for it was members of the White Conduit who persuaded Thomas Lord to give up the Islington ground and find another nearer central London.
For a detailed discussion of the original drawings for this print and for no. 201, see Dennis Rose, 'Georgians at Play', *Country Life*, 30 December 1982, pp. 2094–5.
1927–11–26–59 Potter Coll. – 187.a.5

77

G. or R. NEIL (*fl.* 1780s)

Representation of the Noble GAME of CRICKET, as played . . . near White Conduit House

Engraving by George Noble (*fl.* 1786–1809);
120 × 190 mm; pub. A. Hogg, 1787.
1880–11–13–5011 Crace XXXII, 56, 202

78

Unknown artist with monogram: 'J C' (*fl. c.* 1798)

Cricket with a View of Eton College

Engraving by R. Silvester (*fl.* 1800–25); 505 × 660 mm (cut impression); pub. by the engraver, 1803.
The lines are nos 21–4 from Gray's 'Ode on a Distant Prospect of Eton College':
 'Say, Father THAMES, for thou hast seen
 Full many a sprightly race
 Disporting on thy margent green
 The paths of pleasure trace . . .'
1856–10–11–108

79

THOMAS ROWLANDSON (1756–1827)

Rural Sports or a Cricket Match Extraordinary

Hand-coloured etching; 241 × 344 mm; 1811/12.
The match between the women of Hampshire and Surrey really took place at Balls Pond, Newington, on 3 October 1811. The Hampshire team was victorious after a match lasting three days. The original watercolour is at Lord's.
1935–5–22–10(226) 282 c.1. 'Caricatures' Vol x

RURAL SPORTS OR A CRICKET MATCH EXTRAORDINARY.

On Wenesday October 5 1811. A Singular Cricket Match took place at Balls Pond Newington. The Players on both sides were 22 Women 11 Hampshire against 11 Surrey. The Match was made between two Gentlemen Noblemen of the respective Counties for 500 Guineas aside. The Performers in the Contest were of all Ages and Sizes.

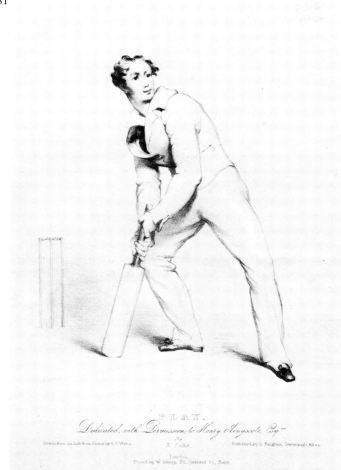

PLAY.

Dedicated, with Permission, to Henry Kingscote, Esq."

by

N. Felix.

Drawn from the Life & on Stone by G. F. Watts.

Published by S. Knight, Sweetings Alley.

London.

Printed by W. Sharp, 72, Gerrard St., Soho.

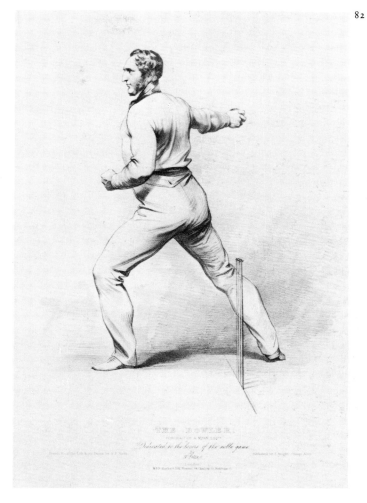

THE BOWLER.

PORTRAIT OF A YOUNG LAD.

Dedicated to the lovers of the noble game

by

N. Felix.

80

ISAAC ROBERT CRUIKSHANK (1789–1856)

North East View of the Cricket Grounds at Darnall near Sheffield, Yorkshire

Pen and brown ink; 99 × 143 mm; datable *c.* 1827.
A recently discovered study for an aquatint of 1827 by the artist, not in the collection. Darnall was an important ground for about four years from 1825. However, being further out of Sheffield than the Hyde Park ground it failed financially, and after 1829 no important matches were played there.
1983.U.2068

81

GEORGE FREDERICK WATTS, O.M., R.A. (1817–1904)

PLAY – Batsman on guard

Lithograph; 290 × 250 mm; Plate 1 to a series of five lithographs showing batting strokes; pub. S. Knights, 1837.
The original drawings are at Lord's.
1885-5-9-1580 165.b.31

82

GEORGE FREDERICK WATTS, O.M., R.A. (1817–1904)

The Bowler – Alfred Mynn

Lithograph; 410 × 312 mm; pub. S. Knights, *c.* 1838.

Mynn (1807–61) was the renowned fast bowler of his time. He was over six feet tall and weighed between eighteen and twenty stone. In *Scores and Biographies*, Arthur Haygarth wrote: 'his bowling was very fast and ripping, round-armed and of a good length . . . it was always considered one of the sights at cricket to see Mynn advance and deliver the ball'.
1885-5-9-1579

83

WILLIAM DRUMMOND (*fl.* 1800–50)

Thomas Box – Wicket-keeper

Hand-coloured lithograph by W. Walton (*fl.* 1840); 270 × 205 mm (cut impression); *c.* 1840.
Box (1808–76) was the outstanding wicket-keeper for the All-England Eleven who 'kept' for the team for nineteen years. He died suddenly while working the telegraph in the Middlesex and Nottinghamshire match of 1876.
1949-4-11-5267

84

NICHOLAS WANOSTROCHT (author) (1804–76)

'Felix on the Bat': being a scientific inquiry into the use of the cricket bat . . . also the laws of Cricket, as revised by the Marylebone Club, 1845, 1st ed.

Coloured lithograph; 240 × 178 mm; opening facing page 16, Chapter IV – *Forward!*.
The earliest colour plate book devoted to cricket.
BL 785.i 32

85

JOHN CORBET ANDERSON (1827–1907)

William Hillyer/Sketches at Lords, No. 3

Lithograph; 370 × 300 mm; pub. by the artist and
R. Dark, 1850.
William Hillyer (1813–61) was one of the great bowlers of
his time. A contemporary admirer, Mr. Gale, wrote of
him:

> 'one of the very best, bar none, who ever took a ball in
> hand; [he] struggled up to the bowling crease like a
> waiter carrying a lot of hot plates and anxious to set them
> down; round-arm bowler, a little below the shoulder,
> and 'death on the wicket'. . . . It is said Hillyer's
> bowling was so true that he could put a ball on a
> sixpence, but he always bowled for the wicket-keeper.'

1954–7–20–2

86

JOHN CORBET ANDERSON (1827–1907)

Joseph Guy of Nottingham

Lithograph; 325 × 206 mm; pub. by the artist and
F. Lillywhite, 1853.
Guy (1814–73) was one of the best batsmen of the 1840s,
and was particularly successful against fast bowling. His
style was so graceful that a contemporary remarked, 'Joe
Guy, all ease and elegance, fit to play before the Queen in
her Majesty's parlour'.

1954–7–20–4

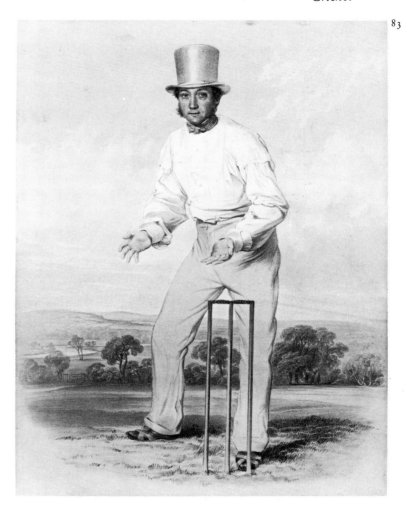

87

JOHN CORBET ANDERSON (1827–1907)

John Wisden

Hand-coloured lithograph; 315 × 201 mm; pub. by the artist and F. Lillywhite, 1853.
Wisden (1826–84) played for Sussex and the All-England Eleven. In 1850, playing for the North against the South, he became the first bowler to clean bowl all ten wickets in an innings of a major match. He is best remembered, however, for founding *Wisden's Cricketers' Almanack* which first appeared in 1864 and remains the standard work of reference on the game.
1954-7-20-3

88

GEORGE DU MAURIER (1834–96)

The University Cricket Match at Lords

Wood-engraving; 114 × 177 mm; illustration to *London Society*, May 1863.
1922-4-10-59

89

CHARLES SAMUEL KEENE (1823–91)

The Ladies' Cricket Club – Matches to come

Hand-coloured etching; 122 × 220 mm; extending frontispiece to *Mr Punch's Pocket Book*, 1869.
1871-8-12-5695 298.a.29 *Plate 7*

90

SIR LESLIE WARD ('Spy') (1851–1922)

The Demon Bowler (Spofforth)

Chromolithograph; 309 × 184 mm; pub. in *Vanity Fair*, 13 July 1878.
Frederick Robert Spofforth (1853–1926) played for New South Wales, Victoria and Australia. In eighteen test matches against England between 1876 and 1886 he took ninety-four wickets.
1943-11-13-464

91

SIR LESLIE WARD ('Spy') (1851–1922)

Repton, Oxford and Somerset (Palairet)

Chromolithograph; 309 × 184 mm; pub. in *Vanity Fair*, 6 August 1903.
Lionel Charles Hamilton Palairet (1870–1933) was a great batsman with a perfect stance, orthodox method and enormous power in driving. He was perhaps at his peak playing for Somerset in the 1890s.
1943-11-13-558

92

SIR LESLIE WARD ('Spy') (1851–1922)

Yorkshire (Hirst)

Chromolithograph; 309 × 184 mm; pub. in *Vanity Fair*, 20 August 1903.
George Hirst (1871–1954) was a great all-rounder, who

"IT'S ALL IN THE GAME"

94

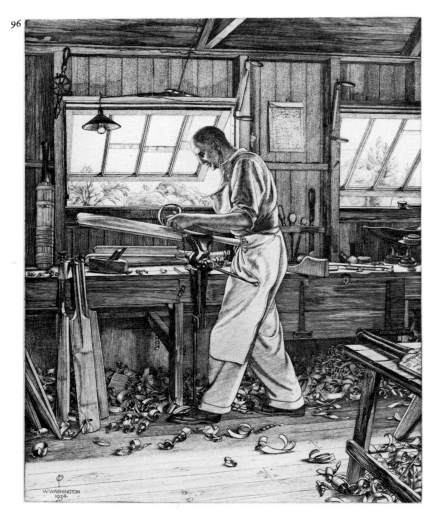

W.WASHINGTON
1934

played in many test matches. He achieved the double of a thousand runs and a hundred wickets for his county in fourteen seasons, and in 1906 he made 2,385 runs and took 208 wickets.

1943–11–13–545

93

SIR LESLIE WARD ('Spy') (1851–1922)

Plum (Warner)

Chromolithograph; 390 × 184 mm; pub. in *Vanity Fair*, 3 September 1903.
Sir Pelham 'Plum' Warner (1873–1963) was captain of Middlesex from 1908 to 1920 and of the England Eleven which recovered the 'Ashes' on the tour of Australia of 1903–4. He was a regularly high scoring batsman, especially at his home ground of Lord's, where a stand now bears his name.

1943–11–13–567

94

HENRY MAYO BATEMAN (1887–1970)

IT'S ALL IN THE GAME

Pen and indian ink; 363 × 500 mm; signed and dated 1920.
1951–9–10–2

95

ANNA KATRINA ZINKEISEN (1901–1976)

Oval Test Match (London Transport Poster)

Colour lithograph; 256 × 314 mm; *c.* 1930.
1981.U.581 Plate 8

96
WILLIAM WASHINGTON (1885–1956)

The Cricket Bat Maker

Engraving; 275 × 219 mm; 1934.
1949–4–11–713

Fencing

97
MARCELLUS LAROON [II] (1648/9 or
1653–1701/2)

Sword and Dagger Guard

Pencil, brown ink and wash, indented for transfer;
178 × 295 mm.
For the engraving after this drawing see the next entry.
1874–8–8–2262

98
WILLIAM ELDER (*fl.* 1680–1700)

Engraving in reverse of the above drawing for pl. 8 of *The
Art of Defence*, *c.* 1699; 195 × 300 mm.

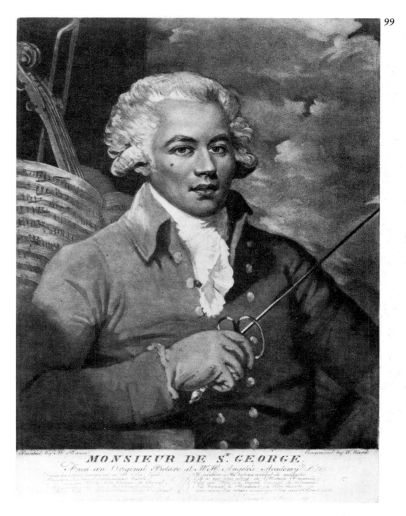

MONSIEUR DE S.^T GEORGE.
From an Original Picture at W.^M Angelo's Academy &c.

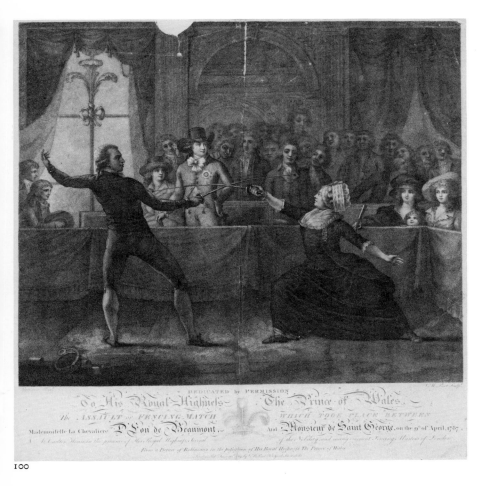

See R. Raines *Marcellus Laroon*, 1966 pp. 100–1 for a detailed account of this rare book, only three copies of which are recorded.
1934–7–9–1(6) 166.c.24

99
MATHER BROWN (*c.* 1763–1831)

Monsieur de St George (1745–99)

Colour mezzotint by William Ward, A. E. (1766–1826); 380 × 280 mm; pub. Bradshaw, 1788.
Born at Guadaloupe, St George was a notable violinist as well as a fencer. It is possible that 'M. de St George' may have been an adopted name based on the 'St George' – a term for a defensive parry.
1905–11–10–75

100
CHARLES JEAN ROBINEAU (*fl.* 1789)

A Fencing Match between Mademoiselle La Chevaliere D'Eon de Beaumont and Monsieur de St George, 1787

Stipple engraving by Victor Marie Picot (1744–1802); 485 × 480 mm (cut impression); 1789.
Charles Geneviève D'Eon de Beaumont (1728–1810) qualified as a doctor of law, acted as a secret agent for Louis xv in Russia in 1755, presenting himself as a woman to the Empress Elizabeth. On his return to France he assumed to the rank of Captain of Dragoons, a promotion made during his absence. After a brief but distinguished army career he came to England in 1762. On appearing back in France wearing his captain's uniform, he was ordered to wear

garments 'proper for a woman'. He lived again in England from 1785 until his death, supporting himself by exhibitions of fencing. Any doubts as to his true sex were dispelled at his post-mortem.
1857–3–8–219

101

JOHN RAPHAEL SMITH (1752–1812)

Henry Angelo – A Fencer

Mezzotint engraved by B. F. Scott (*fl.* 1790/92); 299 × 192 mm; pub. by the engraver, 1791.
Angelo (1760–1839?) took over the fencing academy of his father, Domenico Tremamondo (1716–1802), in 1785. He moved in distinguished company which included Fox and Sheridan, and his 'Reminiscences' (1830) and 'Angelo's Picnic' (1834) contain many amusing anecdotes of his circle.
K.68–107

102

ISAAC ROBERT CRUIKSHANK (1789–1856) and GEORGE CRUIKSHANK (1792–1878)

Fencing at the Rooms in St James's Street

Coloured aquatint; 132 × 212 mm; plate to Pierce Egan's *Life in London*, 1821, p. 252.
1935–9–16–1

Fishing

103

FRANCIS BARLOW (?) (?1626–1704)

Angling

Engraving; 352 × 216 mm; plate 43 to part v of *The Gentleman's Recreation* by Richard Blome (d. 1705), 1686.
1847–3–1–295

104

JOHANN ZOFFANY, R.A. (1733–1810)

Portrait of Master Sayer Fishing

Mezzotint by Richard Houston (1722–75); 502 × 354 mm; pub. R. Sayer, 1772.
Probably James Sayer, the son of Robert Sayer, the printseller and publisher of this print.
1902–10–11–2711

105a–d

SAMUEL HOWITT (1756–1822)

Fly Fishing, *Pike Fishing*, pub. 1798
Minnow Fishing, *Worm Fishing*, pub. 1799

Engravings; 155 × 203 mm.
1850–10–14–699 to 702

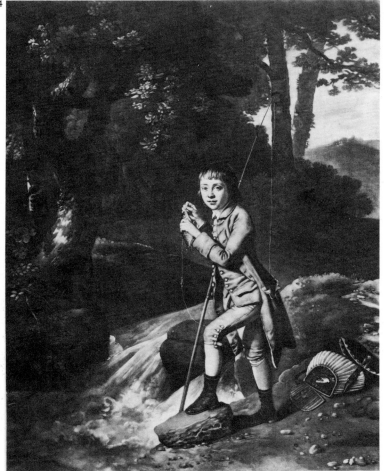

106
SIR FRANCIS SEYMOUR HADEN
(1819–1910)

Grayling Fishing

Mezzotint; 191 × 301 mm; 1897.
1910–4–21–268

107
ROBERT SPENCE (1871–1964)

Izaak Walton

Etching; 128 × 202 mm.
1911–11–27–45

108
ROBERT SARGENT AUSTIN, R.A.
(1895–1973)

The Fisherman

Engraving; 197 × 177 mm; 1927.
Austin made this plate at Bures, Suffolk, in August 1927.
1930–7–12–103

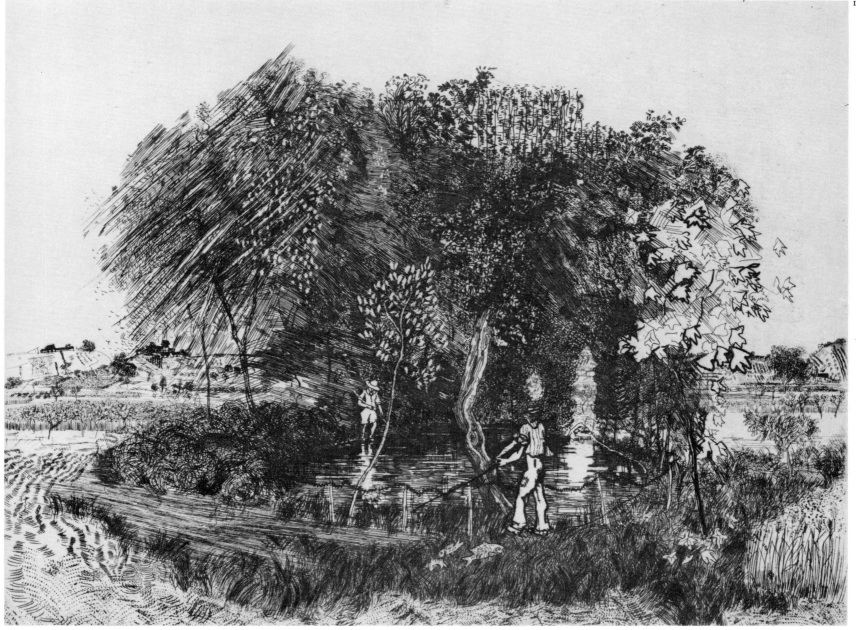

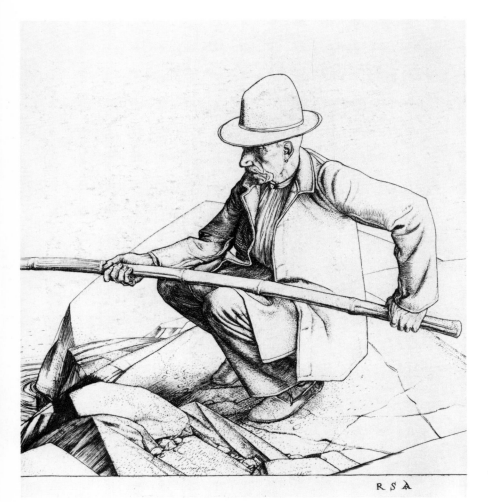

109

ANTHONY GROSS, R.A. (b. 1905)

Canal de Bourgogne

Etching; 207 × 317 mm; 1935/6.
1949–4–11–321

110

ANTHONY GROSS, R.A. (b. 1905)

Fish Pond

Etching and drypoint; 214 × 279 mm; 1935/6.
1969–6–14–63

Football

111

THOMAS WEBSTER, R.A. (1800–86)

Foot-ball

Steel engraving by Henry Lemon (1823 – after 1882);
536 × 1013 mm; pub. by Moore, McQueen and Co., 1864.
The painting was exhibited at the Royal Academy in 1839
(no. 363).
1983.U.2111

112

PAUL NASH (1889–1946)

Pony, the Footballer

Woodcut; 77 × 77 mm; proof illustration to *Cotswold Characters* by John Drinkwater, Yale University Press, 1921, signed and dated by the artist.
1970–9–19–36

113

EDWARD MONTGOMERY O'RORKE DICKEY, C.B.E. (b.1894)

Newcastle Quay

Woodcut; 109 × 140 mm.
1924–2–9–82

114

JAMES SYLVESTER HOLLAND (b.1905)

'Here they come'

Colour lithograph; 228 × 350 mm; 1940s; pub. Artists International Association, Everyman Prints no. 24.
1940–2–21–13

113

115 (detail)

Golf

115

PAUL SANDBY, R.A. (1730/1–1809)

Edinburgh Castle with Golfers in foreground

Watercolours; 291 × 467 mm; bears the artist's collector's mark, lower right.

If the date of the drawing is *c.* 1746–7 (when Sandby was working in Scotland), then this is, at least by thirty years, the earliest representation of golf being played in Scotland. Golf developed its present form in Scotland and has a traceable history of over five hundred years. The rules prepared by the Honourable Company of Edinburgh Golfers in 1744 were the prototype from which later rules for golf were developed by the Royal and Ancient Club at St Andrews, founded in 1754. The use of caddies is an unusual feature of the scene.

1904–8–19–2

116

LEMUEL FRANCIS ABBOTT (1760–1803)

William Innes Esq/To the Society of Goffers at Blackheath . . .

Mezzotint by Valentine Green, A. E. (1739–1813); 640 × 427 mm (cut impression); pub. by the artist, 1790. A companion print to no. 117. Innes was a friend of Callender and a previous captain of the club. The print gives a view of the course where James I introduced golf to

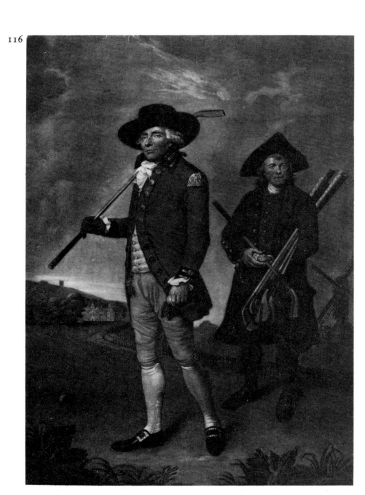

England from Scotland in 1608. The original painting is in the possession of the Royal Blackheath Golf Club, Eltham Lodge.
1871–5–13–18

117

LEMUEL FRANCIS ABBOTT (1760–1803)

Henry Callender Esq/To the Society of Goffers, at Blackheath . . .

Mezzotint by William Ward, A. E. (1762–1826); 651 × 428 mm; pub. by the engraver, 1812.
The Society of Goffers at Blackheath, now the Royal Blackheath Golf Club, was established in 1608. Henry Callender was first its secretary, and then its captain in 1790, 1801 and 1807. The medal and epaulette are badges of office gained when he became the club's first captain-general in 1808. The original painting is in the possession of the Royal Blackheath Golf Club, Eltham Lodge.
1902–10–11–6201

118

SIR LESLIE WARD ('Spy') (1851–1922)

Mr Horace Hutchinson

Chromolithograph; 319 × 190 mm; pub. in *Vanity Fair*, 19 July 1890.
Horatio Gordon Hutchinson (1859–1932) was an eminent golfer from the early 1880s until 1907. He won the Amateur Championship in 1886 and 1887, and was a

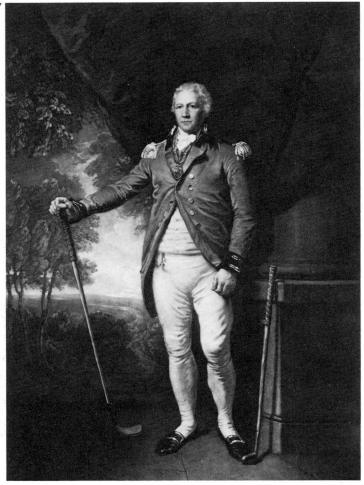

117

finalist on two other occasions, and he was the first Englishman to captain the Royal and Ancient Club at St Andrews.
1983.U.2021

119

SIR LESLIE WARD ('Spy') (1851–1922)

Hoylake (Horace Hilton)

Chromolithograph; 320 × 189 mm; pub. in *Vanity Fair*, 16 July 1903.
Harold Horsfall 'Horace' Hilton (1869–1942) was one of the most scientific golfers. He won the Open Championship twice, in 1892 and 1897. He also won the Amateur Championship four times and became the first player, and only British golfer, to hold both U.S. and British Amateur titles at the same time.
1943–11–13–544

Horse-racing

120

FRANCIS BARLOW (?) (?1626–1704)

Horse Raceing

Engraving; 371 × 224 mm; Plate 6 to part 1 of *The Gentleman's Recreation* by Richard Blome (d. 1705), 1686.
1847–3–6–330

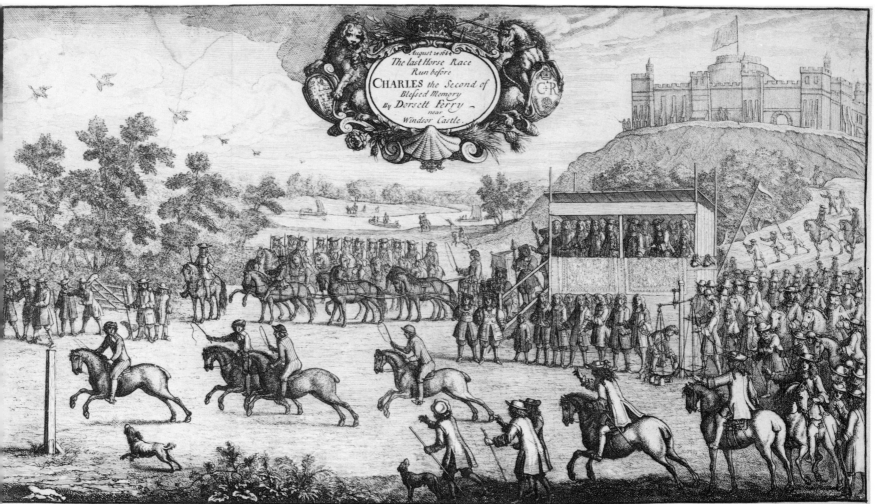

121

FRANCIS BARLOW (?1626–1704)

The Last Horse Race Run before Charles the Second/August 24 – 1684

Etching; 370 × 512 mm; pub. P. Tempest and S. Baker, 1687.
The race took place at Datchet Mead, near Windsor, and the print is one of Barlow's last and largest etchings. Charles II was the first monarch to run horses in his own name at meetings at Newmarket and Burford Downs. The Datchet Mead course was abandoned by Queen Anne in favour of Ascot.
1972.U.941

122

JOHN WOOTTON (c. 1683–1764)

Tregonwell Frampton Esq . . . Keeper of ye Running Horses at Newmarket

Mezzotint by John Faber [II] (c. 1684–1756);
390 × 255 mm; n.d.
Frampton (1641–1727) was eighty-six when he died. The date on the print, '1728', and the age of the sitter, '87' (altered by hand to '97') are erroneous. Frampton, the son of a well-to-do Dorset family, spent his youth among the sporting fraternity of the county. He acquired racehorses and became a successful owner, trainer and gambler. Figures in sporting circles at that time were frequently involved in questionable activities, and Frampton was no

exception, but his reputation survived untarnished to earn him the title 'Father of the Turf'.
1902–10–11–1441

123

BARTHOLOMEW DANDRIDGE (1691–c.1755)

Mrs Davenport in riding-dress

Mezzotint by John Faber [II] (c. 1684–1756);
350 × 250 mm; 1730.
1902–10–11–1343

124

THOMAS BEACH (1738–1806)

Richard Tattersall (1724–95)

Mezzotint by John Jones (c. 1745–97); 505 × 350 mm; pub. by the artist, 1787.
Once a lowly groom in a duke's stables, Tattersall rose to be a very influential character in eighteenth-century racing circles. He established premises at Hyde Park Corner to auction horses, where he also let some rooms to the Jockey Club. He was renowned for his integrity in dealing which brought him the patronage of royalty and fashionable society. Conversely, he was also trusted by the unscrupulous Ring who used his premises to meet each Monday to settle its affairs.
1871–12–9–210

125

JOHN NOST SARTORIUS (1759–1828)

Sir Harry Tempest Vanes Horse, Hambletonian, Preparing to start against Mr Cookson's Diamond over the Beacon Course at Newmarket

Stipple engraving, printed in colour with hand-colouring by J. Whessell (*c.* 1760–*c.* 1823); 392 × 537 mm (cut impression); pub. J. Harris, 1800.
This match, run for high stakes between the owners, created such interest that bets were laid of nearly £250,000. *Hambletonian* won narrowly after both horses had been so brutally handled by their jockeys that their future in racing was abruptly curtailed.
1917–12–8–2434 *Plate 3*

126

JACQUES-LAURENT AGASSE (1767–1849)

Preparing to Start

Hand-coloured aquatint by Charles Turner, A. E. (1774–1857); 465 × 615 mm; pub. by R. Ackermann, 1806.
A pair to *Coming In*.
1917–12–8–1095

127

JOSEPH FRANCIS GILBERT (1792–1855)

Priam winning the Gold Cup in 1831 on Goodwood Race Course

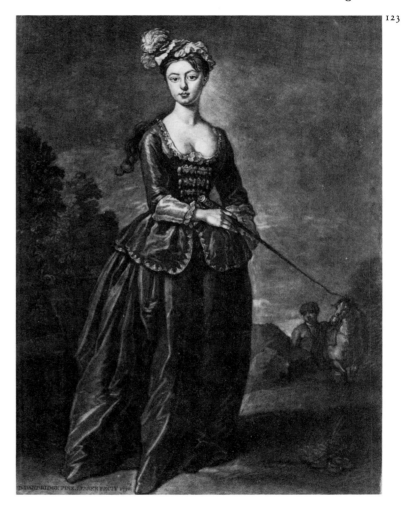

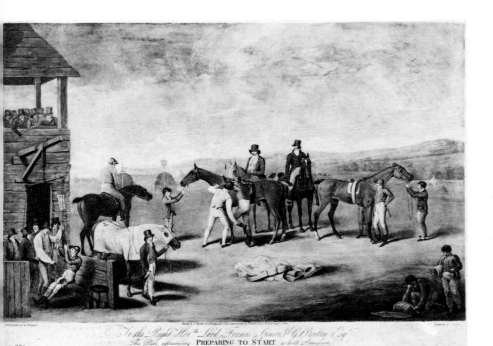

126

Hand-coloured aquatint by John Heaviside Clark (1771–1863); 420 × 679 mm (cut impression); pub. by the artist [1831].
Priam won the Derby Stakes of 1830 and afterwards many other important races. He ranks as one of the great horses in racing history.
1949–4–11–5250

128

JAMES POLLARD (1792–1867)

EPSOM: The Grand Stand

Aquatint printed in colour with some hand-colouring by Charles Hunt (1806–after 1870); 296 × 460 mm; pub. R. Ackermann, 1836.
Plate 4 from a set of six.
1933–10–14–102

129

JAMES POLLARD (1792–1867)

EPSOM: Settling day at Tattersall's

Aquatint printed in colour with some hand-colouring by Charles Hunt (1806–after 1870); 296 × 460 mm; pub. R. Ackermann, 1836.
Plate 6 from a set of six. 'Settling day', a weekly event, took place at Tattersall's at Hyde Park Corner. The Ring, a group of gamblers, met on Mondays to settle their shady transactions. The original painting of 1835 is in the Paul Mellon Collection.
1933–10–14–104

130

JAMES POLLARD (1792–1867)

DONCASTER GRAND STAND: Race for the Gold Cup

Hand-coloured aquatint by Richard Gilson Reeve (1803–89);
283 × 391 mm (cut impression); pub. T. McLean, 1836.
No. 2 from a set of four entitled *British Horse Racing*. The
Doncaster Gold Cup was inaugurated in 1801.
1949–4–11–5255

131

FRANCIS CALCRAFT TURNER
(c. 1782–1846)

Vale of Aylesbury Steeple Chase

Aquatint, partly hand-coloured by Charles Hunt
(1806–after 1870) and George Hunt (*fl.* 1820–40);
384 × 575 mm; pub. J. Moore, 1836.
Plate 1 from a set of four. Steeplechasing developed from
individual challenges to larger contests when riders chased
across country taking every fence they met. In 1830 the
first St Alban's Steeplechase was organised on a circular
course. Interest in the sport increased and by 1842 there
were sixty-six annual meetings, the most important being
Aintree, Cheltenham and the Vale of Aylesbury.
1933–4–8–2

132

HENRY ALKEN (1785–1851)

*The First Steeple-Chace on Record: The large field near
Biles's Corner*

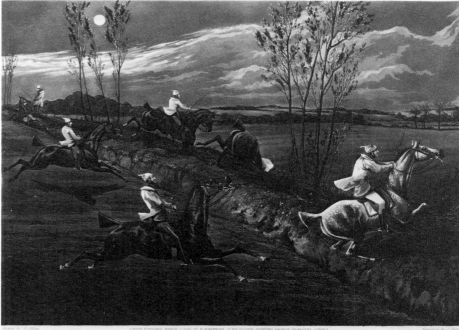

132

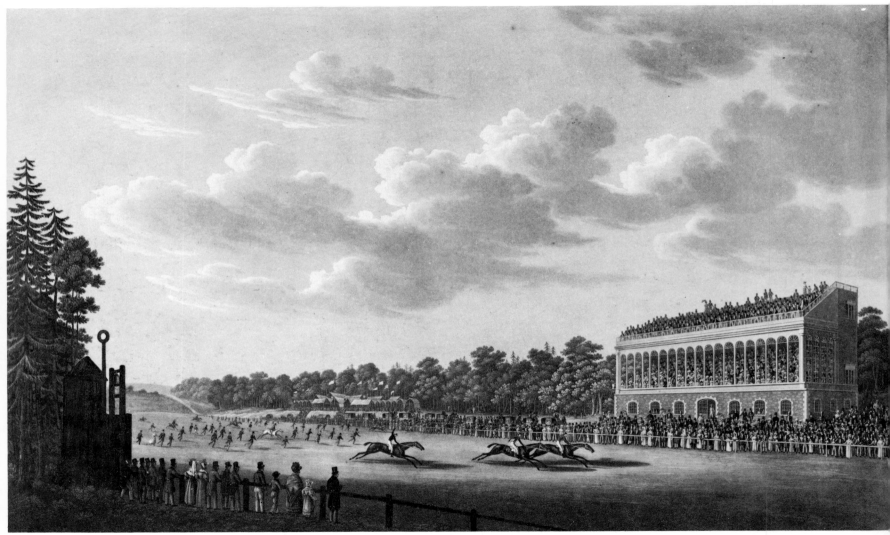

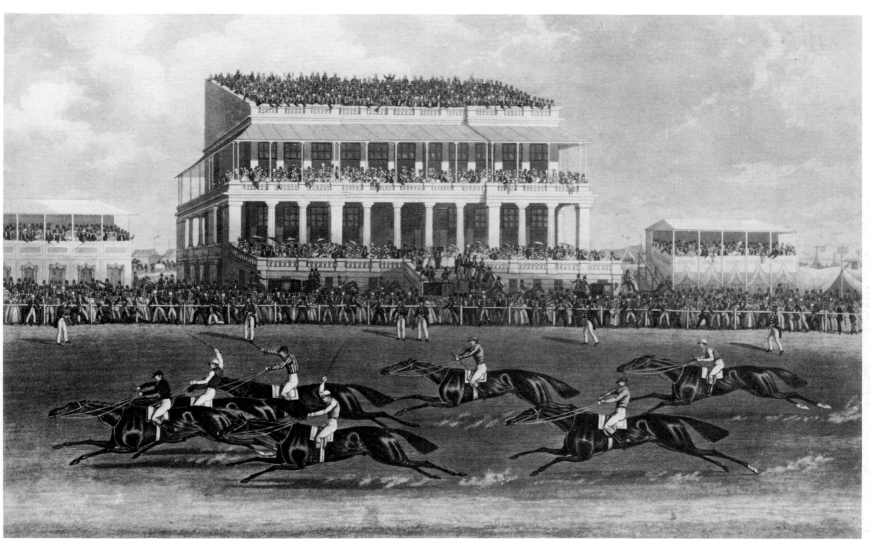

Hand-coloured aquatint by John Harris (1811–65);
350 × 416 mm; pub. R. Ackermann, 1839.
Plate 2 from a set of four. A fictitious event, the text of
which, written by Sydney Cooper, appeared in the first
number of the *Sporting Review*.
1940–2–10–4

133
ANSON A. MARTIN (*fl*. 1840–61)

Jockeys of the South of England

Lithograph by G. B. Black; 369 × 519 mm; pub. by the
artist, *c*. 1850.
A pair to *The Northern Jockeys*. A sheet of thirty-one
portraits including Samuel Chifney [1] and Jem (or Jim)
Robinson who in 1824 won the Derby on *Cedric*, the Oaks
on *Cobweb* and got married, all in the same week. For this
unique achievement he was awarded £1,000.
1914–8–10–194

134
ANONYMOUS

The Derby 1873

Lithograph; mounted fan, 1873.
In the centre, a view of the race at Epsom; on either side,
portraits of winners, with names of owners and jockeys
from 1857 to 1872. A space on the handle is left blank for
1873.
1891–7–13–105

135
VERA WILLOUGHBY (1870–1939)

DERBY DAY: Eclipse (London Transport Poster)

Colour lithograph; 352 × 337 mm; 1932.
Eclipse was bred in 1764 and was never beaten in a two-year
career. He subsequently sired over three hundred winners.
1934–3–27–14

Hunting and Coursing

136
FRANCIS BARLOW (?) (?1626–1704)

Earthing the Fox

Engraving; 345 × 209 mm; Plate 28 to part III of *The
Gentleman's Recreation* by Richard Blome (d. 1705); 1686.
1847–3–6–311

137
FRANCIS BARLOW (?) (?1626–1704)

Fox Hunting – Uncoupling and casting of ye Hounds

Engraving; 345 × 209 mm; plate 27 to part III of *The
Gentleman's Recreation* by Richard Blome (d. 1705); 1686.
1847–3–6–309

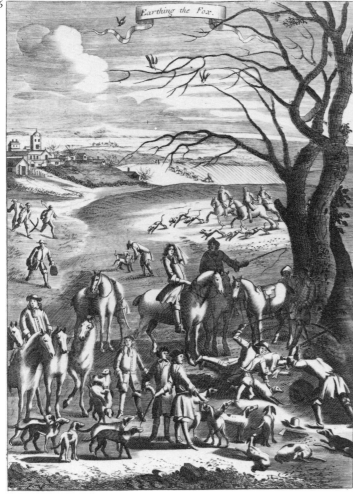

Earthing the Fox.

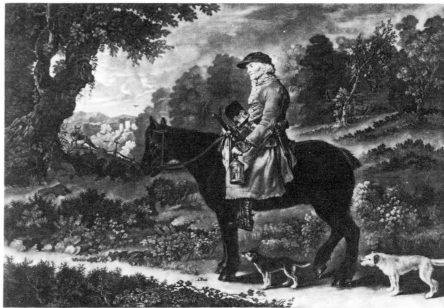

Arthur Wentworth of Bulmer near Castle Howard, Yorkshire. Aged 75.
Earth Stopper to Charles late Earl of Carlisle, to Hon. Brownlow Darley Esq.

138

138

NATHAN DRAKE (*c.* 1728–78)

Arthur Wentworth . . . Earth Stopper

Mezzotint by Valentine Green, A. E. (1739–1813);
280 × 350 mm; pub. 1767.
Earth stopping involves blocking up all escape holes in
which a fox might hide and is normally done the night

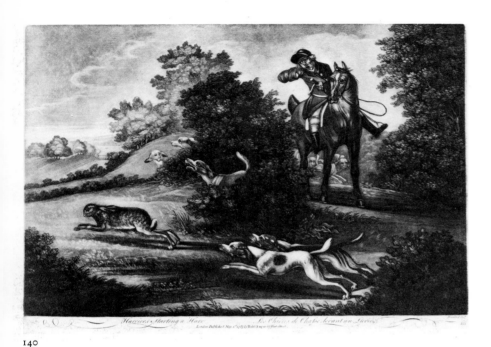

140

before a hunt, hence the lantern and spade. A painting of identical composition by Drake in a private collection is dated 1769.
1851–3–8–709

139

FRANCIS SARTORIUS (1734–1804)

Cotton Decks . . . A Noted Breaker of Pointers

Mezzotint by Robert Laurie (*c.* 1755–1836);
275 × 355 mm; pub. 1772.
1853–1–12–1705

140

JAMES SEYMOUR (?1702–52)

Harriers starting a Hare

Mezzotint by Thomas Burford (1710–*c.* 1770);
250 × 350 mm; pub. by Robert Sayer, 1787.
1939–7–14–21

141

GEORGE STUBBS, A.R.A. (1724–1806)

Two Hunters

Colour stipple engraving by George Townley Stubbs
(1756–1815); 402 × 504 mm; pub. by the engraver, 1792.
1873–7–12–563

142

DEAN WOLSTENHOLME [1] (1757–1837)

Stag Hunting

Hand-coloured aquatint by Richard Reeve (*fl.* 1800–1810);
345 × 435 mm; pub. by the engraver, 1808.
Plate 2 of a set of four.
1939–7–14–10

143

RICHARD BARRETT DAVIS (1782–1854)

The Chase (Fox Hounds running breast high)

Hand-coloured aquatint by Thomas Sutherland
(*c.* 1785–1838); 317 × 699 mm; pub. R. Ackermann, 1819.
1941–10–11–51

144

JAMES POLLARD (1792–1867)

His Majesty King Geo III returning from Hunting

Aquatint by Matthew Dubourg (*fl.* 1786–1838);
400 × 535 mm; pub. by E. Orme, 1820.
A pair to *Royal Hunt in Windsor Park.*
1866–11–14–689

145

JAMES POLLARD (1792–1867)

Coursing. A view in Hatfield Park

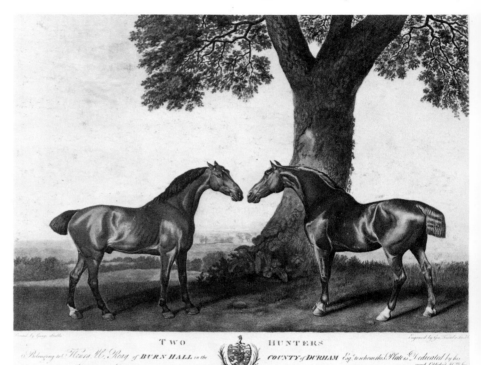

141

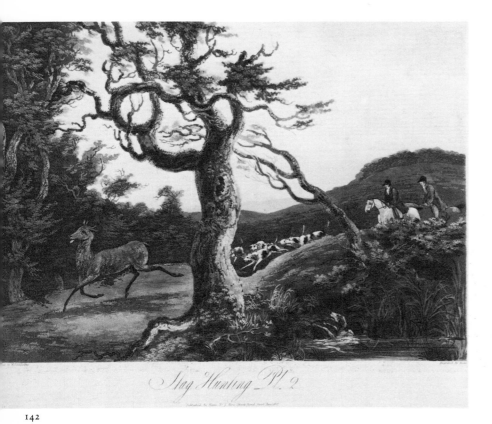

Stag Hunting Pl. 2

142

Hand-coloured aquatint; 319 × 480 mm; pub. R. Pollard and Sons, 1824.
1939–7–14–16

146
T. N. H. WALSH (*fl* 1879)

A Pleasant Ride Home

Hand-coloured aquatint by Edward Gilbert Hester (d. 1903); 397 × 534 mm; modern impression, printed 1949; originally pub. by R. Dodson, 1879.
1949–9–30–4

147
ROBERT POLHILL BEVAN (1865–1925)

Found!

Lithograph; 252 × 338 mm; Plate 2 from 4 *Hunting Scenes, Somerset 1898.*
1926–5–11–48

148a–c
JULIA MAVROGORDATO (b. 1903)

Reynard the Fox; Hounds in Bracken; Fox crossing the Stream

Lino-cuts in colours; each approx. 115 × 118 mm.
1932–5–14–39; 1932–7–30–2, 3

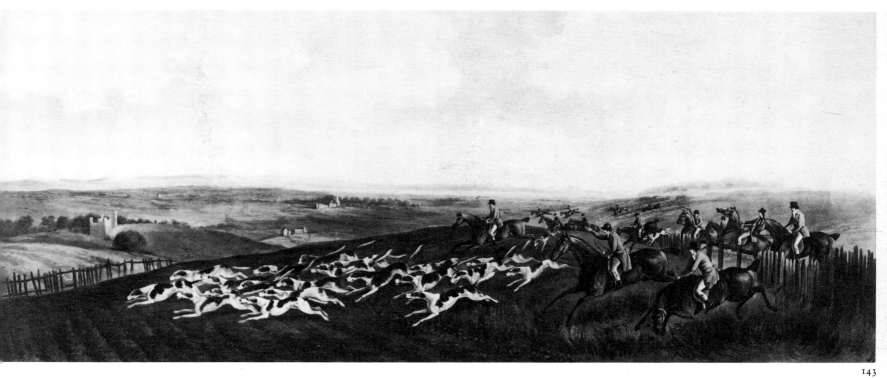

143

81

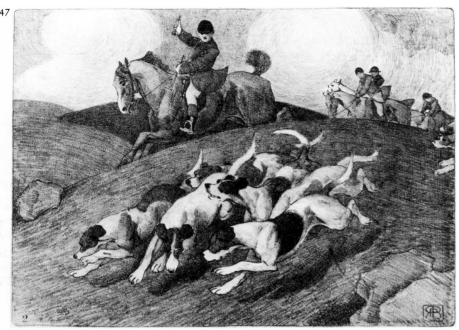

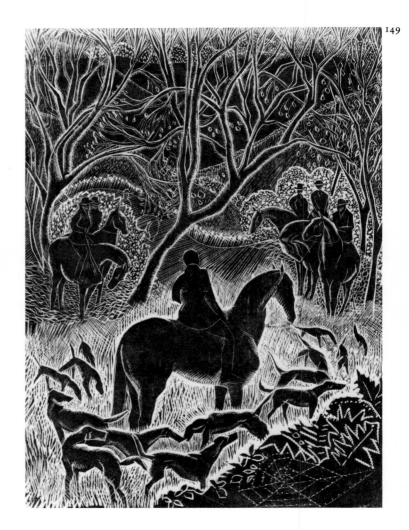

149
JULIA MAVROGORDATO (b. 1903)

Autumn Morning

Woodcut; 178 × 128 mm.
1941–2–8–71

Rowing and Yachting

ROWING

150

THOMAS ROWLANDSON (1756–1827)

The Race for Doggett's Coat and Badge

Pen, indian ink and watercolours; 235 × 380 mm.
Thomas Doggett (d. 1721), a famous Irish comedian, left
money for Thames watermen to perpetuate a rowing race
to be held on 1 August each year 'for ever'. The first race
was in 1716 and the contest still takes place today: it is the
oldest sculling race in the world. Doggett's aim, which was
to encourage a young apprentice in his first year as a
tradesman on the river, has resulted in producing the best
known professionals including nearly all the British
champions and some world champions. The original course
was from the White Swan, London Bridge, to the Swan
Inn, Chelsea. This sheet shows the finish.
1856–7–12–923

151

JOHN THOMAS SERRES (1759–1825)

A Boat Race on the River Isis.

Aquatint by John Whessell (c. 1750–c. 1823);
405 × 535 mm; pub. by the engraver, 1822.
1940–2–21–1

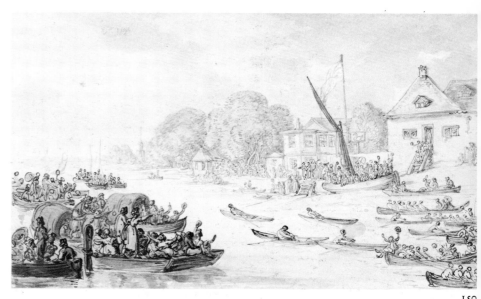

150

151

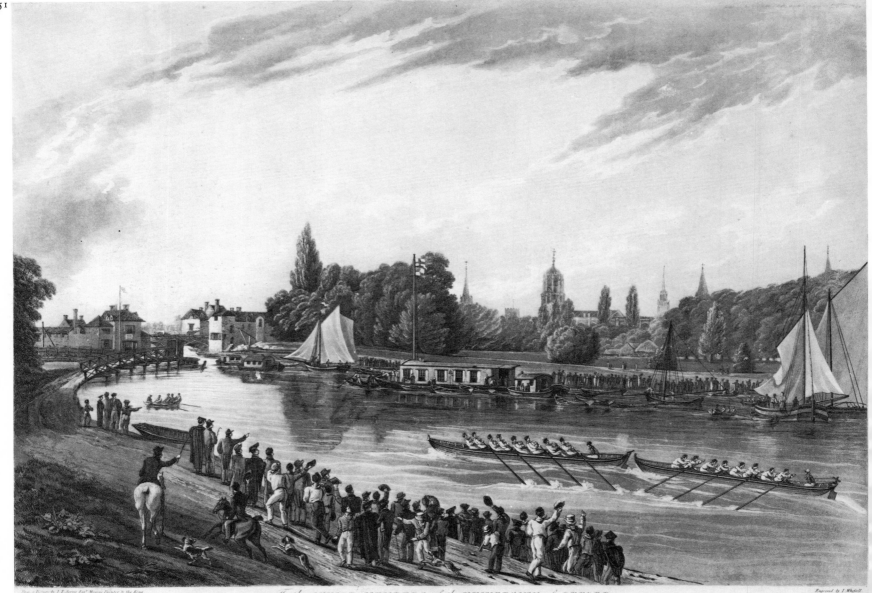

To the JUNIOR MEMBERS of the UNIVERSITY of OXFORD.

This Print of a BOAT RACE on the RIVER ISIS, Is respectfully Inscribed, by their obedient humble Serv.t John Whessell.

152

Attributed to
ROBERT HAVELL [1] (1769–1832)

The First Cambridge University Crew

Hand-coloured aquatint; 310 × 510 mm; *c.* 1830.
At this date the University Boat clubs had no colours under which to row. Cambridge wore pink sashes in honour of their captain, and it was not until 1836 that they adopted light blue as their colour. The first race between Oxford and Cambridge took place at Henley on 10 June 1829 and Oxford won 'easily'. The correspondent of *London Society* wrote: 'Never shall I forget the shout that rose among the hills. It has never fallen to my lot to hear such a shout since'.

1949–4–11–5265 *Plate 4*

153

E. F. LAMBERT (*fl.* 1823–46)

Westminster Bridge, Surry Shore (Lyon's Boatbuilders Yard)

Hand-coloured aquatint by Henry Pyall (1795–1833); 325 × 405 mm; pub. by W. Lyon (the boatbuilders), 1831. In the days when bridges across the Thames were few, ferrymen were in regular demand. The wealthy employed watermen on their staffs just as they would coachmen, and provided them with liveries of appropriate dignity. Hence some of the watermen here are wearing silk hats while others are in uniforms.

1880–11–13–1282 Crace IV.25.62

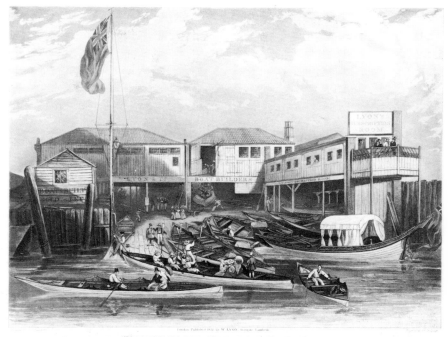

WESTMINSTER BRIDGE, SURRY SHORE.

153

154

EDMOND MORIN (1824–82)

Outrigger races on the Thames –The Jockeys of the River

Wood-engraving by Henry Duff Linton (1815–99) from a French illustrated magazine; 228 × 331 mm; 1857.
1903–4–20–70

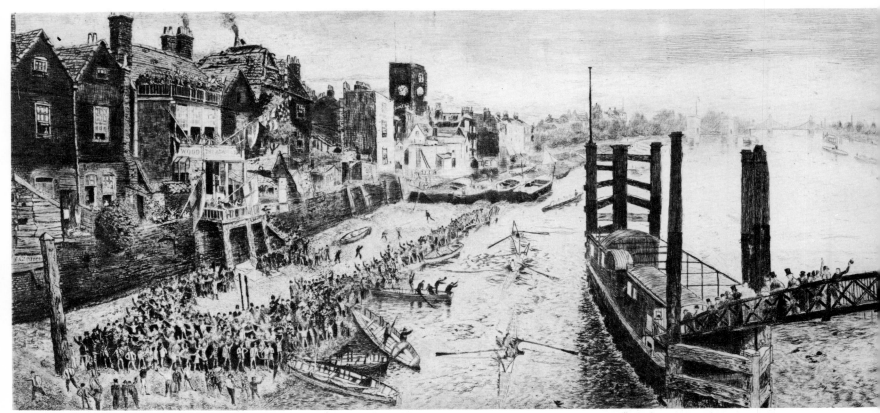

155

86

155

WALTER GREAVES (1846–1930)

The Last Chelsea Regatta

Etching; 261 × 554 mm; 1871.
This traditional festival was about to be ended by the demolition of the old waterfront and the building of the Chelsea Embankment. Racing at low water, the competitors were cheered by crowds on the balconies of the Adam and Eve tavern, the steamboat pier below Battersea Bridge and the foreshore.
1939–4–24–1

156

ANONYMOUS

The Oxford and Cambridge Boat Race

Lithograph; 380 × 605 mm; pub. S. Lipschitz, 1871.
Cambridge won by a length.
1981.U.182

157

CHARLES PAINE (*fl.* 1920s)

The Boat Race 1921 (London Transport Poster)

Colour lithograph; 750 × 502 mm; 1921.
Cambridge won by a length.
1921–4–21–7

UNDERGROUND

BOAT RACE 1921

BOOK TO HAMMERSMITH, CHISWICK PARK OR PUTNEY BRIDGE.

160

YACHTING

158

SIR OSWALD WALTER BRIERLY (1817–94)

The 'America' Winning at Cowes, 1851

Colour lithograph with some hand-colouring by Thomas Goldsworth Dutton (1819/20–1891); 383 × 603 mm (lacks full inscription); pub. R. Ackermann and Co., 1851.
The *America*, built in 1850, was the first yacht to cross the Atlantic. In the race of 22 August 1851 against the Royal

Yacht Squadron, the vessel defeated all comers. The effect of the victory was to prompt numerous attempts to recover the trophy by British yachtsmen.
1948–4–10–201

159

THOMAS SEWELL ROBINS (1814–80)

The "SVERIGE" 280 tons, winning the Royal Thames Yacht Club match on June 1st 1853

Colour lithograph with some hand-colouring by Thomas Goldsworth Dutton (1819/20–1891); 246 × 642 mm; pub. R. Ackermann, 1854.
The Swedish schooner won the race depicted in the print but was disqualified – a verdict which led to much bad feeling and a lawsuit. *Sverige*, her fore-topmast lost, crossed the line twenty-five seconds ahead of *Rosalind*. Just before the finish *Rosalind* carried away her jib-boom, as shown in the print. At the finish *Rosalind* and *Sverige* were in collision. As *Sverige* had already been foul of the *Violet*, for which she earned disqualification, the race went to *Rosalind*.
1948–4–10–198

160

THOMAS GOLDSWORTH DUTTON (1819/20–1891)

The start for the Great Atlantic Race, December 11th 1866

Colour lithograph; 356 × 604 mm; pub. W. Foster, 1866.
The event from Sandy Hook Point (New Jersey) to the

Needles took place in the dead of an Atlantic winter.
Henrietta, on the far left of the print, owned by Mr
Gordon Bennett and navigated by Captain Samuel Samuels
(famous as commander of the American packet ship
Dreadnought), proved the winner in thirteen days,
twenty-two hours. A suggested return match against
British yachts did not take place.
1948–4–10–179

161

THOMAS GOLDSWORTH DUTTON
(1819/20–1891)

*The Anglo American Yacht race round the Isle of Wight,
August 25th 1868*

Colour lithograph; 366 × 610 mm; pub. W. Foster, 1868.
The largest yacht in the print, the *Cambria* was the winner.
She was the first yacht to try to win back the 'America
Cup', and on her way across the Atlantic in 1870 sailed a
match with the American schooner *Dauntless* (See no. 162)
and just beat her by an hour.
1948–4–10–202

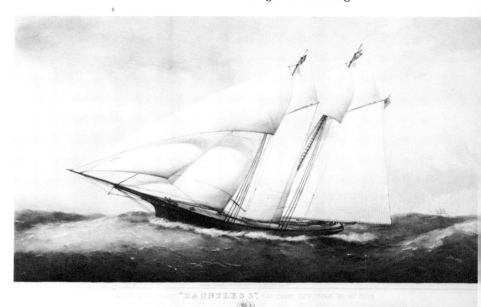

"DAUNTLESS"

162

162

THOMAS GOLDSWORTH DUTTON
(1819/20–1891)

*Schooner Yacht "DAUNTLESS", 262 tons, New-York
Yacht Club*

Colour lithograph; 359 × 605 mm; pub. W. Foster, 1869.
1948–4–10–191

163

CHARLES ROBERT RICKETT (*fl.* 1868–79)

*Royal Thames Yacht Club, Ocean Match from Nore to
Dover – for the Queen's Cup, June 24th 1874*

Lithograph by Maclure and Macdonald; 459 × 715 mm.
1948–4–10–203 *Plate 5*

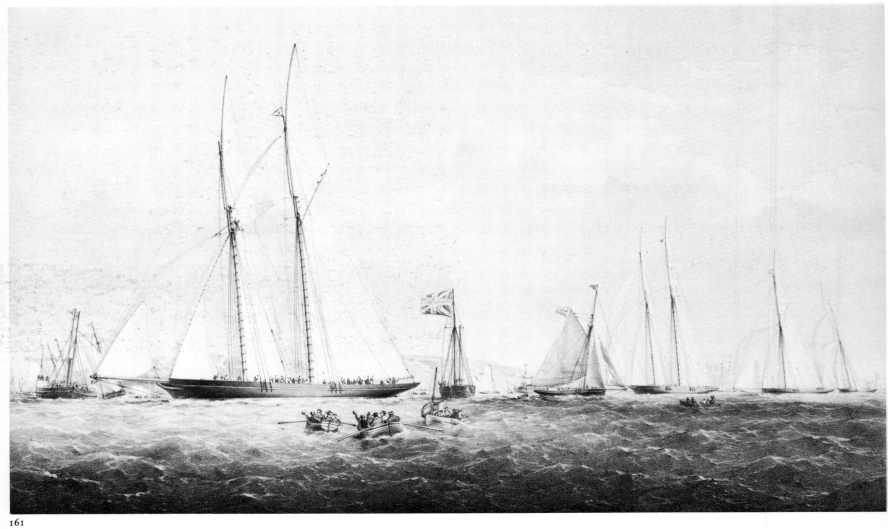

164

WILLIAM BROWN MACDOUGALL
(1868–1936)

Regatta on Barton Broad

Woodcut; 164 × 260 mm; signed; *c.* 1925.
1926–4–12–279

Shooting, Hawking and Falconry

SHOOTING

165a–d

GEORGE STUBBS, A.R.A. (1724–1806)

Shooting

A set of four etchings and engravings by William Woollett (1735–85); 425 × 543 mm; pub. 30 August 1770, 1770 or 1771, 16 August 1770 and 5 November 1771 respectively. Stubbs exhibited the paintings of these subjects at the Society of Artists between 1767 and 1770. All are now in the Yale Center for British Art, New Haven, U.S.A.
1852–7–5–206 and 207, 1842–11–12–32, 1852–7–5–209

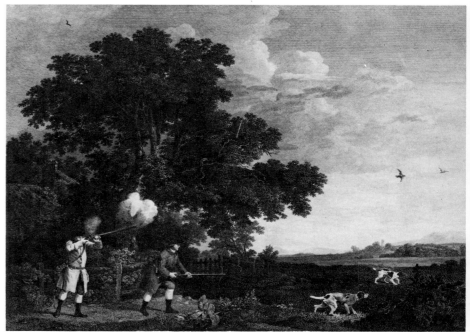

165c

166

JOHN COLLET (*c.* 1725–80)

The Ladies Shooting Poney

Mezzotint by an unknown engraver; 153 × 114 mm; pub. Carington Bowles, 1780.
1981.U.472

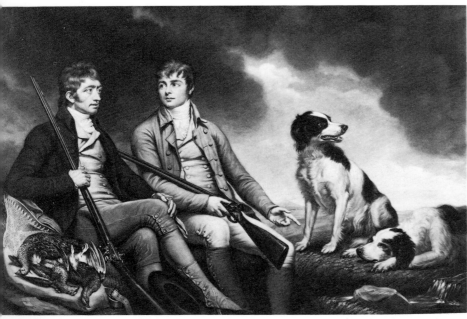

167

167

JAMES NORTHCOTE, R.A. (1745–1831)

Grouse Shooters in the Forest of Bowland

Mezzotint by George Dawe, R.A. (1781–1829);
480 × 605 mm; pub. by the engraver, 1804.
The two sportsmen in Northcote's painting are William
Assheton (1758–1833), who was High Sheriff of Lancaster
in 1792, and the Rev. T. H. Dixon Hoste (1779–1805),
who was a fellow of Trinity College, Cambridge. The
painting was done for the Parker family of Browsholme
Hall in the Forest of Bowland, with whom it remains
today.
1902–10–11–594

168

ROBERT POLLARD (1755–1839)

Pigeon Shooting

Hand-coloured aquatint; 260 × 387 mm; pub. by the
engraver, 1813.
1939–7–14–39

169

SIR ROBERT FRANKLAND, Bt (1784–1849)

Shooting Signals

Hand-coloured etching; 225 × 270 mm; c. 1815.
Presumably an unofficial system of signalling in the field.
1939–7–14–35

170

EDWARD DUNCAN (1803–82)

Wild Duck Shooting

Hand-coloured aquatint; 210 × 297 mm; pub. T. Gosden,
c. 1825.
1872–8–10–741

171

HENRY ALKEN (1785–1851)

*Pigeon Shooting. Red-House Club, Battersea
Members shooting for the Gold Cup, 1828*

Hand-coloured aquatint by Richard Gilson Reeve
(1803–89); 350 × 503 mm; pub. 1828.
Live pigeons were released from traps: a precursor of
modern clay-pigeon shooting.
The Red House, Battersea, was a tea garden with extensive
grounds used for shooting matches. It was demolished in
1850.
1939–7–14–15

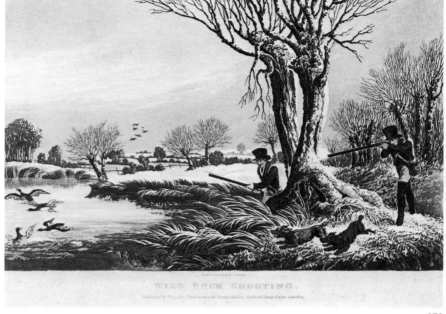

170

HAWKING

172

FRANCIS BARLOW (?1626–1704)

Hern Hawking

Etching by Wenceslaus Hollar (1607–77); 179 × 229 mm;
Plate 9 to *Severall Wayes /of /Hunting, Hawking, and
Fish /ing, According to the English Manner* . . . by an
unknown author; pub. London, *c.* 1671.
Private Collection

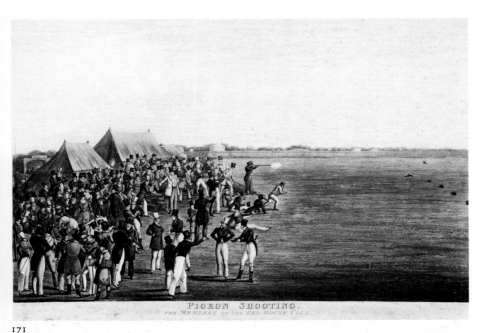

PIGEON SHOOTING.
THE MEMBERS OF THE RED HOUSE CLUB.

171

173
FRANCIS BARLOW (?1626–1704)

Feasant Hawking

Etching by Wenceslaus Hollar (1607–77); 179 × 229 mm;
Plate 7 to *Severall Wayes/of/Hunting, Hawking and
Fish/ing According to the English Manner . . .* by an
unknown author; pub. London, *c.* 1671.
Private Collection

174
FRANCIS BARLOW (?) (?1626–1704)

Takeing Birds with a Low-Bell and Batt Fowling

Engraving; 345 × 209 mm; Plate 40 to Part IV of *The
Gentleman's Recreation* by Richard Blome (d. 1705), 1686.
1847–3–6–299

175
SAWREY GILPIN, R.A. (1733–1807)

Hawking

Engraving by Thomas Morris (*fl.* 1750–1800);
462 × 550 mm; pub. 1780.
'This represents a true scene that happened a few miles
from York. The Falconer, Colonel Thornton, who is
shown setting up his hawk from a heron which it has killed,

left his horse outside the paling, when the animal immediately leapt over, following his master, and stood in the attitude here represented.' (Siltzer, p. 124)
1867–12–14–296

176

JAMES HOWE (1789–1836)

Hawking: Malcolm Fleming of Barochan (1745–1811)

Mezzotint and stipple engraving by Charles Turner, A. E. (1774–1857); 560 × 631 mm; pub. A. Finlay, 1816.
Malcolm Fleming of Barochan was representative of one of the few Scottish families known to have been interested in falconry. He is shown on horseback with his falconer John Anderson (d. 1833) and John Harvey. The building in the background is Barochan Tower.
1868–12–12–42

177

HENRY ALKEN (1785–1851)

Hawking

Hand-coloured aquatint by John Heaviside Clark (c. 1764–1863); 280 × 375 mm; pub. T. McLean, 1820.
No. 1 from a set of fifty entitled *The National Sports of Great Britain*, 1820.
Hawking declined with the invention of the fowling piece, which made the killing of game more sure, and the enclosures of land which reduced the large areas available for the sport. Falconers heartily despised the armed

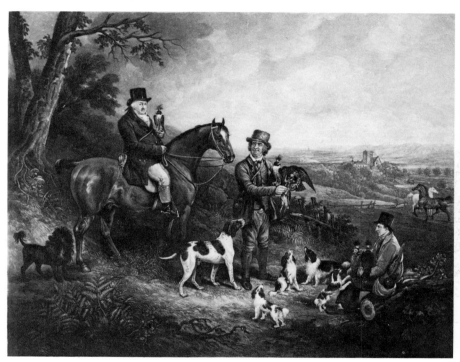

176

sportsman and their toast reflects their attitude – 'A health to all that shot and missed.' This line was originally spoken by Petruchio in Act v Scene 2 of *The Taming of the Shrew*.
1943–10–9–2

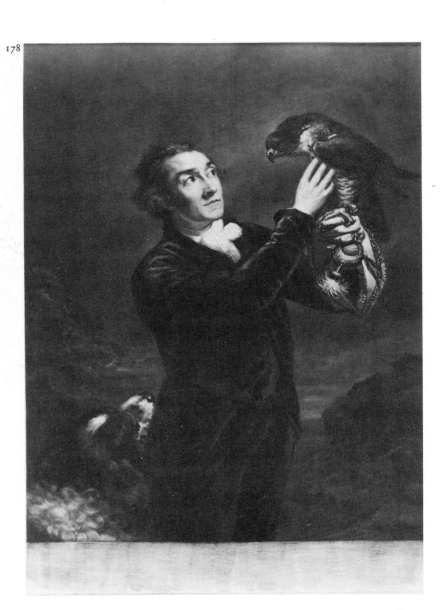

178

JAMES NORTHCOTE, R.A. (1746–1831)

The Falconer/Mr Samuel Northcote of Plymouth

Mezzotint by Samuel William Reynolds [1] (1773–1835);
504 × 355 mm; pub. J. R. Smith, 1797.
The painting was done in 1789 for the Duke of Dorset. It
was exhibited at the Royal Academy in 1797 as
'Northcote's brother', no. 226.
1902–10–11–4017

179

ISAAC ROBERT CRUIKSHANK (1789–1856)

John Anderson, Falconer (d. 1833)

Aquatint; 296 × 222 mm; pub. G. Humphrey, 1821.
Anderson, a famous Scottish falconer, here attending the
coronation of George IV, 19 July 1821.
1852–10–9–562

180

HERBERT JOHNSON HARVEY (1884–1928)

The Falconer

Etching; 227 × 177 mm.
1932–12–8–1

Skating

181a,b

ANONYMOUS

Two Views of the Frost Fair which took place when the River Thames froze in 1683

(a) Woodcut; 234 × 359 mm. (b) Etching (frontispiece); 263 × 372 mm; 1684.

Among the sports being enjoyed on the ice as well as skating are football, sledging, fox hunting, bull-baiting, ninepins, throwing at cocks and playing at pigeon holes. Throwing at cocks consisted of tying a bird to a stake and hurling missiles at it until it died. The winner of this barbarous pastime had the bird for his dinner. Playing at pigeon holes appears to have involved the rolling of balls through tiny holes cut in a low wooden frame.

The frost of December 1683 lasted for over two months until February 1684. The varied activities on the ice over that period became the subject of many ballads and broadsides, one not inappropriately entitled 'Great Britain's Wonder or London's Admiration'.

1931–11–14–360,365

182

JOHN HAYNES (*fl.* 1730–50)

The South West Prospect of the Dropping Well at Knaresborough, as it appear'd in the Great Frost, January MDCCXXXIX (1739)

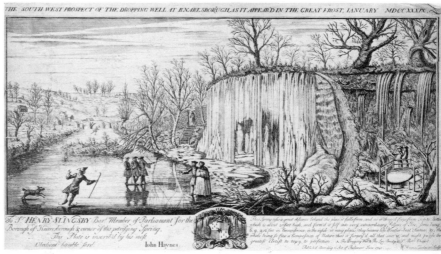

182

Etching; 375 × 642 mm; 1740.
1880–11–13–5881

183

W. DARLING (*fl.* 1770–90)

The Fencing Position

Etching; 178 × 188 mm; Plate 3 (not 4, as in the text) to *A Treatise on Skating* by Lieutenant Robert Jones, R.A., 1772 (first edition), the first published work on figure-skating.

One of the advantages Jones claims for skating is that 'it is

Wonders on the Deep; OR, The most Exact Description of the Frozen RIVER of THAMES:

Also to what was Remarkably Observed thereon in the last great Frost, which began about the middle of *December*, 1683. and ended on the 8th. of *February* following. Together with a brief *Chronology* of all the Memorable (strong) Frosts, for almost 600 Years. And what happened in them to the Northern Kingdoms.

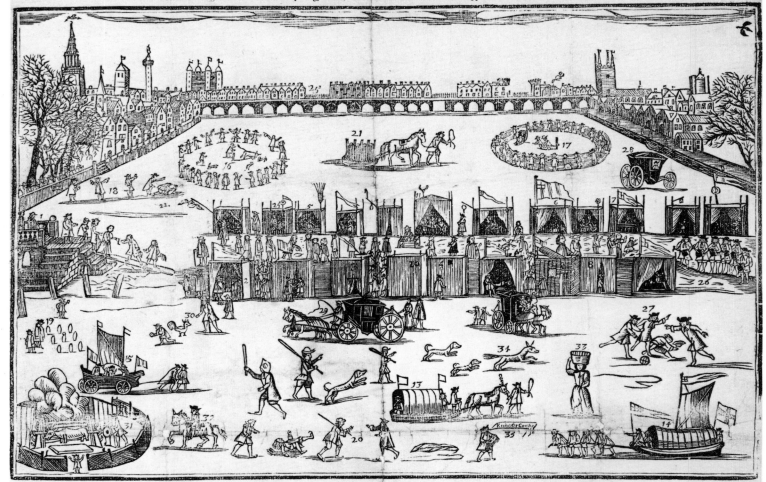

AN EXPLANATION OF THE PIECE IN FIGURES.

Figure 1. The Temple-Stairs. 2. The Duke of York's Coffe-House. 3. The Toy-Booth. 4. The Booth with the Phœnix Insur'd. 5 The Roast-Beef-House. 6. The Half-way-House. 7. The Bare-Garden Booth. 8. The Musick-House Booth. 9. The PRINTER'S Booth. 10. The Raffling-Booth. 11. The Horn-Tavern. 12. The Temple-Garden, where people look on Frost-Fair. 13. The Bare drawn with a Horse. 14. The Drum-Boat. 15. The Boat drawn on Wheels by Men. 16. The Bull Bated. 17. The Dutch Chear Sliding round. 18. The Boys Sliding. 19. Playing at Nine-pins. 20. Men Sliding with Skates 21. The Sledges of Coles. 22. The Booth with the Sign of the Flying-Chamber-pot. 23. Boys Climing the Trees in the Temple to see the Bull-Bating. 24. The Toy-Shops. 25. London-Bridge, with the several Prospects of the Monument, the Tower, Bow-Steeple, St. Mary-Overs, &c. 26. The six Tinkers, beating their Kettles upon Temple-Street. 27. The Foot-ball Play. 28. The Coach with three Wheels, mov'd by Clock-work. 29. The common Hackney Coaches. 30. The throwing at the Cock. 31. The Ox-Roasting over-against White-hall, whereof some of the Meat was presented to the King, Queen, and the rest of the Nobility. 32. The Man Riding on the Thames a horse-back, to see the Horse-Race. 33. Hot Ginger-bread, three-half-penny-worth for a penny. 34. The Hunting of the Fox. 35. Knives or Combs, with many Booths for Entertainment not Figured, as viz. The Hoop, the Rose, the three-Tuns, and the Bellows: The Whip and Egg-shell Entertains Good-Fellows.

an excellent preservative against the gout'. However, Jones seems in many ways to be nearer in outlook to our times than to his own – on the role of women for instance. In the eighteenth century it was not deemed suitable for them to disport themselves on the ice. Jones wrote:

> 'For my part, I can see no reason why the ladies are to be excluded . . . No motion could be more happily imagined for setting off an elegant figure to advantage; nor does the minuet itself afford half the opportunity of displaying a pretty foot.'

On the art of skating itself many of his observations are still valid today:

> 'Learners throw their arms about carelessly, or in a wild manner, as if they were catching at something to prevent their falling; which is the very means of throwing them down.'

1931–11–14–628 188.e.9

184

JULIUS CAESAR IBBETSON (1759–1817)

Study of Skaters

Pen, indian ink and wash; 186 × 230 mm; *c.* 1785/6.
1931–11–14–80

185

JULIUS CAESAR IBBETSON (1759–1817)

Winter Amusement, A View in Hyde Park from the Moated House

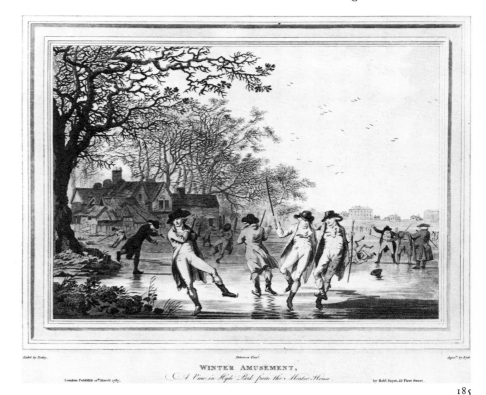

WINTER AMUSEMENT,
A View in Hyde Park from the Moated House.

185

187

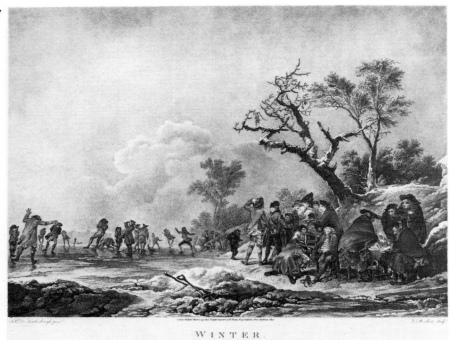

WINTER.

Etching and aquatint by James Tookey (*fl.* 1787–1805) and
John William Edy (spelt here Eyde; 1760–*c.* 1820);
269 × 347 mm; pub. R. Sayer, 1787.
The figures and landscape in this print and in its
companion, no. 186, derive, with some differences, from a
painting – *A View in Hyde Park; a Winter Scene* which
Ibbetson exhibited at the Royal Academy in 1786
(no. 192).
1931–11–14–208

186

JULIUS CAESAR IBBETSON (1759–1817)

*Winter Amusement, A View in Hyde Park from the Sluce at
the East End*

Etching and aquatint by James Tookey (*fl.* 1787–1805) and
John William Edy (spelt here Eyde; 1760–*c.* 1820);
269 × 347 mm; pub. R. Sayer, 1787.
1931–11–14–207

187

PHILIP JAMES DE LOUTHERBOURG,
R.A. (1740–1812)

Winter

Hand-coloured stipple engraving by Victor Marie Picot
(1744–1805); 430 × 544 mm; pub. C. Knight, 1794.
1931–11–14–404

188

ADAM BUCK (1759–1833)

Skating Lovers

Colour aquatint by Piercy Roberts (*fl.* 1795–1828) and
Joseph Constantine Stadler (*fl.* 1780–1824);
452 × 500 mm; pub. W. Holland, 1800.
1932–10–19–1 *Plate 1*

189

JOHN AUGUSTUS ATKINSON
(*c.* 1755–*c.* 1833)

Skaiting

Etching and aquatint; 256 × 376 mm; pub. W. Miller,
1807.
1931–11–14–164

190

JOHN BURNET (1784–1868)

Buckingham House, Middlesex. A Palace of Her Majesty

Aquatint with some hand-colouring by R. Havell and Son;
200 × 299 mm; pub. R. Havell, 1817.
An earlier print of this subject was drawn and engraved by
Burnet for *The Beauties of England and Wales*, 1810.
1931–11–14–175

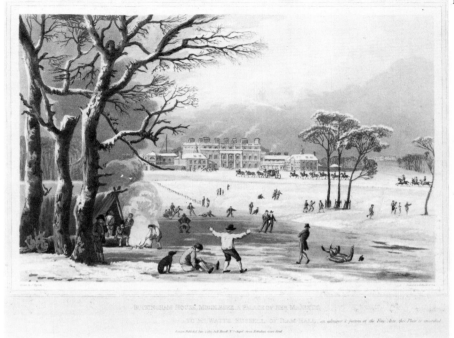

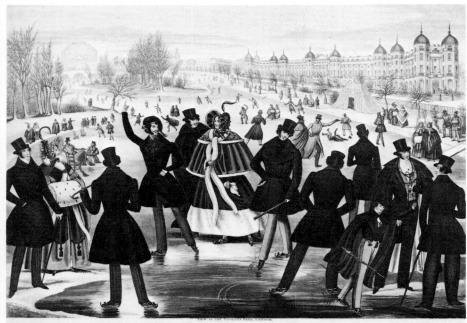

WINTER FASHIONS for 1838 & 39 by B. READ & C? 12, Hart St. Bloomsbury Square, LONDON, and Broad Way, New York. AMERICA.

191

191

ANONYMOUS

Winter Fashions for 1838 and 39. View in the Regents Park, London

Hand-coloured aquatint; 436 × 570 mm; 1838.
1931–11–14–357

192

JOHN BRANDARD (d.1863)

Outside wheel and outside edge backwards

Lithograph; 137 × 89 mm; fig. 5, facing page 38 of *The Art of Skating* by Lieutenant Robert Jones, R.A., with revisions and additions by W. E. Cormack, 4th edition(?), 1855(?).
1931–11–14–627 188.d.3

193

QUENTIN BLAKE (b. 1932)

Design for an advertisement for Guinness

Pen and blue and black ink; watercolours and coloured pencils; 184 × 355 mm.
1971–10–30–5

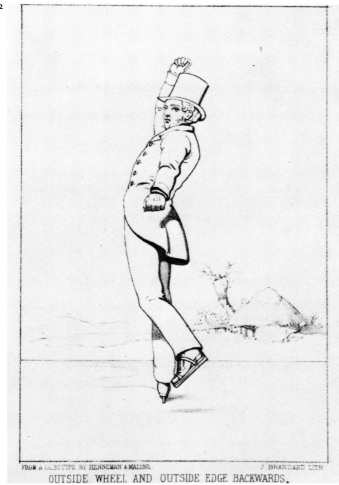

OUTSIDE WHEEL AND OUTSIDE EDGE BACKWARDS.

Tennis, Rackets and Shuttlecock

TENNIS

194
**Attributed to
MATTHÄUS MERIAN the younger** (1621–87)

The High Borne Prince James Duke of Yorke

Etching from *The True Effigies of . . . King Charles . . .
with the . . . Royall Progenie*, p. 10; 190 × 125 mm;
pub. for John Sweeting, 1641.
The game is real tennis, not lawn tennis which came about
in 1874 when Major Walter Wingfield adapted the old game
to the open air. He presented lawn tennis as an alternative
to the increasingly popular croquet.
1868–8–22–852

195
**JOHN HAMILTON MORTIMER,
A.R.A.** (1741–79)

Monsieur Masson the Tennis Player

Mezzotint by Richard Brookshaw (1736–1800?);
505 × 355 mm; pub. J. Wesson, 1769.
Raymond Masson (1740 – ?) is the first of the really great
champions of tennis whose achievements are on record. He

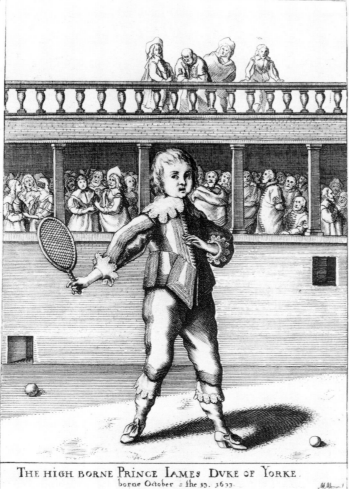

THE HIGH BORNE PRINCE IAMES DVKE OF YORKE.
borne October = the 33. 1633.

could give a '15' advantage to his nearest rival, the elder Charrier. He was the outstanding player of his time despite the fact that he wore spectacles.
1851–3–8–473

196
THOMAS HOSMER SHEPHERD (1793–1864)

The Royal Tennis Court established 1673 in St James's Street, Leicester Square (as it appeared in 1850)

Indian ink wash and watercolours; 170 × 450 mm; 1850. The first court on the site (now Orange Street) was built in about 1634; it closed in 1866.
1880–11–13–3014 Crace XVIII,28.13

197
GEORGE DU MAURIER (1834–96)

"An Unforseen Consequence"

Wood-engraving; 173 × 111 mm; illustration to *Punch*, LXXV.95 (31 August 1878).
1908–4–14–565

198
ANNA KATRINA ZINKEISEN (1901–1976)

Wimbledon Tennis (London Transport Poster)

Colour lithograph; 256 × 314 mm; *c.* 1930.
1981.U.584 *Plate 8*

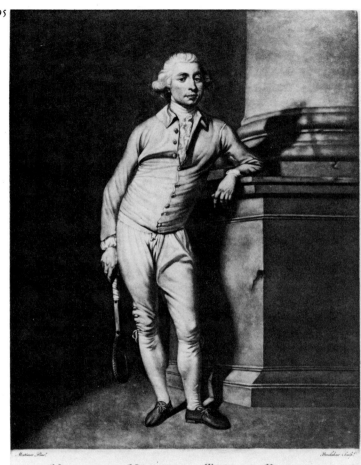

MONSIEUR MASSON the TENNIS PLAYER

FLEET PRISON.

RACKETS

199
THOMAS ROWLANDSON (1756–1827)
and AUGUSTUS CHARLES DE PUGIN
(1762–1832)

Fleet Prison (showing the Racket Court)

203

Colour aquatint by Joseph Constantine Stadler
(*fl.* 1780–1824); 226 × 275 mm; pub. R. Ackermann, 1808.
Plate to *The Microcosm of London*, Vol. II, facing p. 44.
1880–11–13–3254 Crace XIX.122.45

200

ANONYMOUS

King's Bench (A game of rackets)

Aquatint; 214 × 375 mm; *c.* 1810.
Rackets started in the debtors' prisons, the Fleet and the
King's Bench, in the mid-eighteenth century. Many
gentlemen, confined for debt, could lead reasonable lives if
they had friends to support them, and these friends,
familiar with tennis, brought their rackets into the prison
to pass the tedious hours. They played against the high
prison walls and so rackets originated.
1880–11–13–5196 Crace XXXIV.47.16

201

ROBERT DIGHTON (1752–1814)

FIVES, Played at the Tennis Court, Leicester Fields

Engraving by an unknown engraver; 173 × 214 mm;
pub. Carington Bowles, 1788.
The game is rackets and not fives in the modern sense.
Fives was not clearly differentiated from similar ball games
played with bat or hand until the middle of the nineteenth
century. (See also no. 76.)
1880–11–13–3015 Crace XVIII.29.14

202

ANONYMOUS

King's Bench Prison (A game of rackets)

Engraving; 172 × 208 mm; pub. J. McShee, 1823.
1880–11–13–5101 Crace XXIV.42.14

SHUTTLECOCK

203

FRANCIS HAYMAN, R.A. (1708–76)

Battledore and Shittlecock (sic)

Engraving by Nathaniel Parr (1723–after 1751);
295 × 360 mm; pub. T. and J. Bowles, 1743.
The word 'Battledore', meaning a small racket, first occurs
in 1598. The game was first called 'Battledore and
Shuttlecock' in 1719, but the activity dates from medieval
times. The painting, one of the series of recreations (see
no. 73) Hayman painted for the decoration of the supper
boxes in Vauxhall Gardens, is lost.
1862–10–11–616

204

R. DONOLDSON (*fl.* 1755)

Benjamin Griffin Jossia Jackson

Mezzotint by Richard Purcell (d. 1766?); 150 × 112 mm;
printed for George Pulley, 1750(?).
Probably the son of Michael Jackson, who was a
contemporary of Purcell and also a mezzotinter.
1902–10–11–3734

204

R. Donoldson pinx.t R. Purcell fecit

Benjamin Griffin Jossia Jackson

Printed for Geo. Pulley Brides Court Fleet Street.

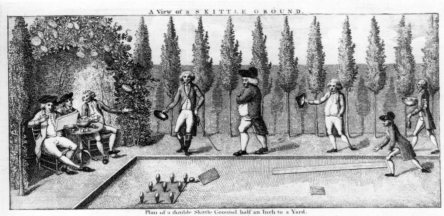

The Sporting Bag

205

ANONYMOUS

Playing at Coits

Engraving; 240 × 350 mm; *c.* 1750.
1868–6–12–2204

206

ANONYMOUS

The Skittle Ground, Merlin's Cave, New River Head, Islington, with rules and instructions for playing

Engraving; 440 × 270 mm; pub. G. Kearsley, 1786.
1880–11–13–4880 Grace XXXII.71.17

207

Unknown Artist with initials J . H . *(fl. 1791)*

A Sand Yacht

Etching and aquatint; 261 × 375 mm; dated 1791.
The Dutch used yachts on both ice and sand in the seventeenth century and were probably the first to employ such vessels for sport. Prints of sand yachts are extremely uncommon.
1938–1–15–21

208

ISAAC ROBERT CRUIKSHANK
(1789–1856)

Going to a Fight

Aquatints; Four strips from a roll of eight, comprising
forty-two parts; each 93 × 533 mm; pub. Sherwood, Neely
and Jones, 1819.
The panorama illustrates the sporting world in all its
variety along the road from Hyde Park Corner to Moulsey
Hurst, Surrey. The latter, near Hampton Court, could
only be reached by ferry, hence it was unlikely that the
magistrates would be able to stop these illegal fights.
1957–5–27–4, 5, 6, 7

209

ANONYMOUS

Johnson's Pedestrian Hobbyhorse Riding School

Hand-coloured aquatint; 285 × 350 mm; pub.
R. Ackermann, 1819.
The velocipede or pedestrian hobbyhorse was invented by
Baron Drais, *c.* 1813, and first shown in Paris. An
improved form was patented by Denis Johnson, a London
coach-maker, in 1818. Each machine cost eight guineas and
riding them became the rage early in 1819. By March of the
same year their use in London had been suppressed by the
police magistrates on account of the crowded streets.
1871–8–12–5309

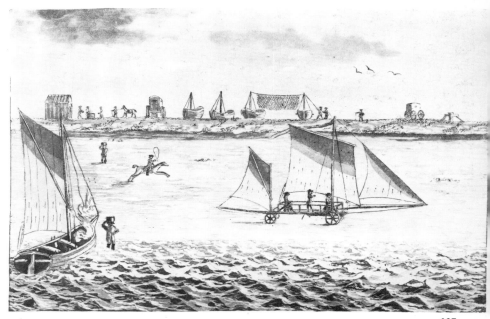

207

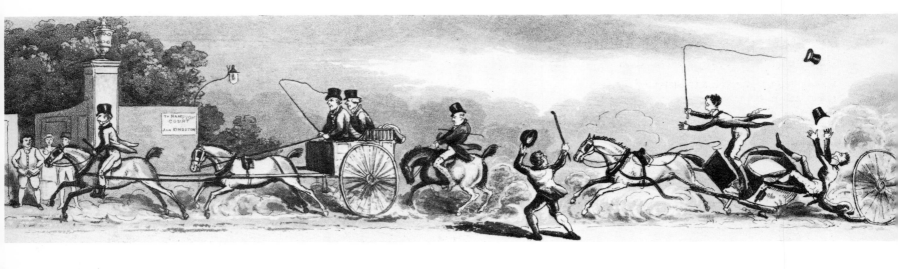

208 (details)

210

ANONYMOUS

Swimming Races, Hyde Park (18 August 1843)

Wood-engraving from an illustrated magazine;
124 × 222 mm.
1862–10–11–508

211

CLAUDE ALLIN SHEPPERSON, A.R.A.
(1867–1921)

Rounders

Etching and drypoint; 200 × 250 mm.
1922–12–13–3

212

DIANA THORNE (**working** 1928)

Stream Line (Greyhound racing)

Etching and drypoint; 149 × 297 mm; signed in pen.
1960–4–9–609

213

JOHN COPLEY (1875–1950)

Hurlingham (Polo)

Drypoint; 373 × 277 mm.
1947–2–24–12

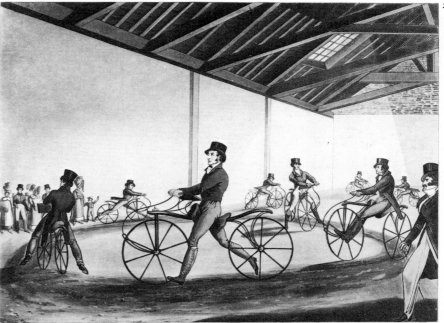

Johnson's Pedestrian Hobbyhorse Riding School,
at 377 Strand & 40 Brewer Street Golden Sqr.

THIS Machine is of the most simple kind, supported by two light wheels running on the same line; the front wheel turning on a pivot, which, by means of a short lever, gives the direction in turning to one side or the other, the hind wheel always running in one direction. The rider mounts it, and seats himself in a saddle conveniently fixed on the back of the horse (if allowed to be called so), and placed in the middle between the wheels; the feet are placed flat on the ground, so that in the first step to give the Machine motion, the heel should be the part of the foot to touch the ground, and so on with the other foot alternately, as if walking on the heels, observing always to begin the movement very gently. In the front, before the rider, is placed a cushion to rest the arms on while the hands hold the lever which gives direction to the Machine, as also to balance it if inclining to either side when the opposite arm is pressed on the cushion.

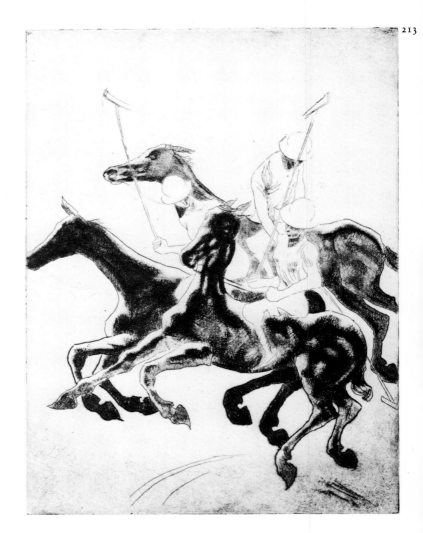

214
GEORGE MAYER MARTON (1893–1960)
Tobogganing

Drypoint; 216 × 346 mm; signed; executed in 1924.
1970–5–12–2

215
LILL TSCHUDI (b.1911)
Ice-Hockey

Colour lino-cut; 260 × 279 mm; probably executed when
the artist, Swiss by birth, was studying in London in
1929/30, and again in 1934.

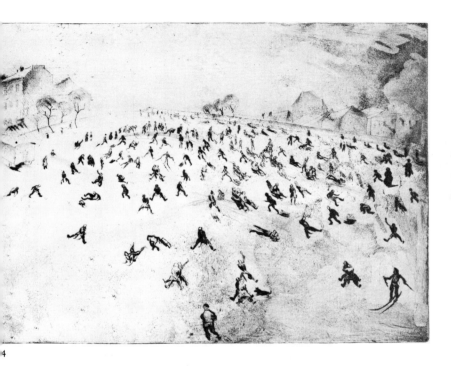

4

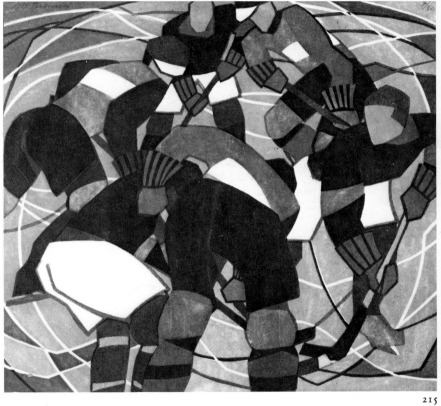

215

The main centre for ice-hockey in London at this time was
Harringay.
1941–2–8–120

Checklist of Prints

Comprising prints in the Department of Prints and Drawings described in Captain Frank Siltzer, *The Story of British Sporting Prints*, 1929. The numbers refer to page numbers in Siltzer. In order to identify some prints more easily, certain titles have been altered to agree with recent catalogues, or with inscriptions on the prints.

Select Bibliography

ABERDARE, Lord, *The Willis Faber book of Tennis and Rackets*, 1980

ALEXANDER, John, *The Conquest of the Air*, 1902

ALTHAM, H. S. and SWANTON, E. W., *History of Cricket*, 1948

ARCHIBALD, E. H. H., *Dictionary of Sea Painters*, 1980

BAILLIE-GROHMAN, W., *Sport in Art*, 1920

BATCHELOR, Denzil, *British Boxing*, 1949
 The Boxing Companion, 1964
 Soccer, 1954

BELLAMY, Rex, *The Story of Squash*, 1978

BENNETT, H. L., *Chipping Campden, A Short History and Guide*, n.d.

BIRD, Dennis L., *Our Skating Heritage*, 1979

BIRKETT, Sir Norman, (introduction) *The Game of Cricket*, 1955

BLAINE, D. P., *Encyclopaedia of Rural Sports*, 1870

BLEW, William, *A History of British Steeple-chasing*, 1901

British Sporting Paintings 1650–1850, Arts Council Exhibition, Hayward Gallery, 1975

BROOK-HART, Denys, *British 19th century Marine Painting*, 1974

BURKE, Edmund, *The History of Archery*, 1958

CARDUS, Neville and ARLOTT, John, *The Noblest Game*, 1969

CLAY, Rotha Mary, *Julius Caesar Ibbetson*, 1948

CLEAVER, Hylton, *A History of Rowing*, 1957

COOMBS, David, *Sport and the Countryside*, 1978

CUNDALL, H. M., *Old Shooting Prints*, Print Collector's Quarterly, Vol. XXII, 1935, pp. 117–38

CUST, L., *Catalogue of the Collection of Fans . . . British Museum*, 1893

DE BEAUMONT, C. L., *Fencing – Ancient Art and Modern Sport*, 1970

Derby Day 200, Royal Academy Exhibition, 1979

EGAN, Pierce, *Life in London*, 1821

EGERTON, Judy, *The Paul Mellon Collection, British Sporting and Animal Paintings 1655-1867*, 1978

FAGAN, Louis, *William Woollett*, 1885

FITTIS, R. S., *Sports and Pastimes of Scotland*, 1891

FLEISCHER, N. and ANDRE, S., *A Pictorial History of Boxing*, 1975

FORD, Horace, *Theory and Practice of Archery*, 1887

FOSTER, F. W., *A Bibliography of Skating*, 1898

FOWLER, G. Herbert, *On the Outside Edge*, 1897

FRANKAU, Julia, *John Raphael Smith*, 1902
 William Ward and James Ward, 1904

GEORGE, Mary Dorothy, *Catalogue of Political and Personal Satires in the British Museum*, 1935–49

GODFREY, Richard T., *Printmaking in Britain*, 1978

GREGO, Joseph, *Rowlandson the Caricaturist*, 1880

HAYES, John, *Rowlandson – Watercolours and Drawings*, 1972

HEATH, E. G., *A History of Target Archery*, 1973

HEATHCOTE, J. M., *Tennis*, 1903

HILTON, H. H. and SMITH, G. G., *The Royal and Ancient Game of Golf*, 1912

HODGSON, J. E., *History of Aeronautics in Great Britain*, 1924

HOLE, Christina, *English Sports and Pastimes*, 1949

LONGRIGG, Roger, *The History of Horse Racing*, 1972
The English Squire and his Sport, 1977

MACPHERSON COLLECTION, The Guildhall Art Gallery, London, *Catalogue of a loan exhibition of Paintings and Prints*, 1928
Whitechapel Art Gallery, *Catalogue of . . . Old Shipping Prints*, 1924

MALLALIEU, Huon, *A Dictionary of British Watercolour Artists up to 1920*, 1976; Illus. 1979

MARCH, Russell, *The Cricketers of Vanity Fair*, 1982

MARSH, W. Lockwood, *Aeronautical Prints and Drawings*, 1924

MARSHALL, Julian, *Annals of Tennis*, 1878

MASSEY, S. M., *Badminton*, 1911

MORTIMER, Roger, *A History of the Derby Stakes*, 1962

NATIONAL SKATING ASSOCIATION, *A History . . . with a catalogue of the Exhibition of Skates and Skating Matters*, 1902

O'DONOGHUE, F. and HAKE, H. M., *Catalogue of Engraved British Portraits in the British Museum*, 1908–25

Oxford Companion to Sports and Games, ed. John Arlott, 1975

PADWICK, E. W., *A Bibliography of Cricket*, 1977

PAGET, Guy, *Sporting Pictures of England*, 1945

PAULSON, Ronald, *Hogarth; His Life, Art and Times*, 2 vols, 1971

PHILLIPS-BIRT, Douglas, *The Cumberland Fleet*, 1975

PIMLOTT, J. A. R., *Recreations*, 1968

POCOCK, Tom, *Chelsea Reach*, 1970

POSTAN, Alexander, *The Complete Graphic Work of Paul Nash*, 1973

Pursuit of Happiness, The, Yale Center for British Art, New Haven, Exhibition, 1977; intro. J. H. Plumb

RAINES, R., *Marcellus Laroon*, 1960

ROBERTS, W., *Sir William Beechey*, 1907

SABIN, V. P., *Old Rowing Prints*, Print Collector's Quarterly, Vol. xx, 1933, pp. 65-77

SELWAY, N. C., *The Regency Road*, 1957
James Pollard 1792–1867, 1965
The Golden Age of Coaching and Sport, 1972

SHEARMAN, Montague, *Football*, 1899

SILTZER, Frank, *The Story of British Sporting Prints*, 1929

SMITH, John Chaloner, *British Mezzotinto Portraits*, 1883

SNELGROVE, D., *Paul Mellon Collection, British Sporting and Animal Prints*, 1981

SPARROW, W. Shaw, *Angling in British Art*, 1923

Sport in Scotland, Scottish National Portrait Gallery, Edinburgh, Exhibition, 1960(?)

STRUTT, J., *The Sports and Pastimes of the People of England*, 1903

THORNBURY, W. and WALFORD, E., *Old and New London*, 6 vols, n.d.

VESME, A. de and CALABI, A., *Francesco Bartolozzi*, 1928

WALKER, Stella, *Sporting Art 1740-1900*, 1972

WARING, B. Thomas, *A Treatise on Archery*, 1832

WEBSTER, Mary, *Johan Zoffany 1733–1810*, National Portrait Gallery Exhibition, 1976

WHYTE, James, *History of the British Turf*, 2 vols, 1840

WYMER, Norman, *Sport in England*, 1949

Index of Artists and Engravers

The numbers cited in this and the following index are catalogue numbers.

General Index

The Plates

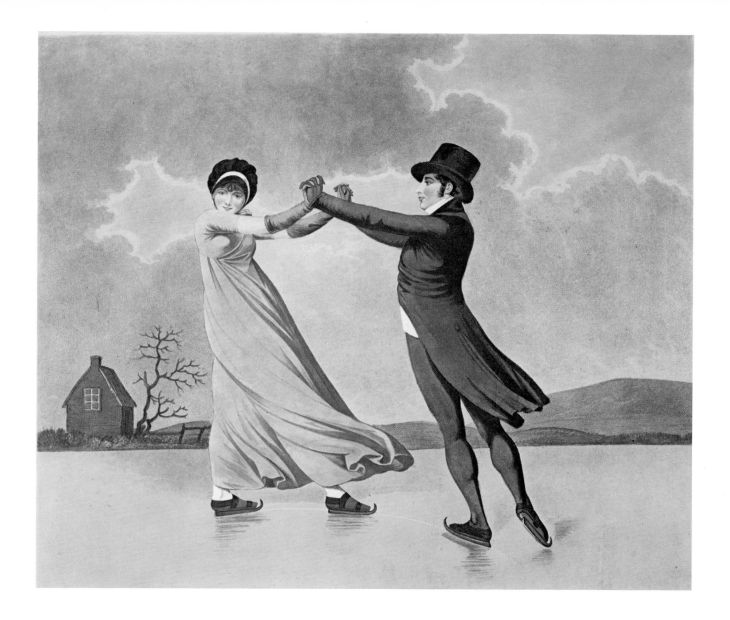

PLATE 1 Adam Buck *Skating Lovers* 1800

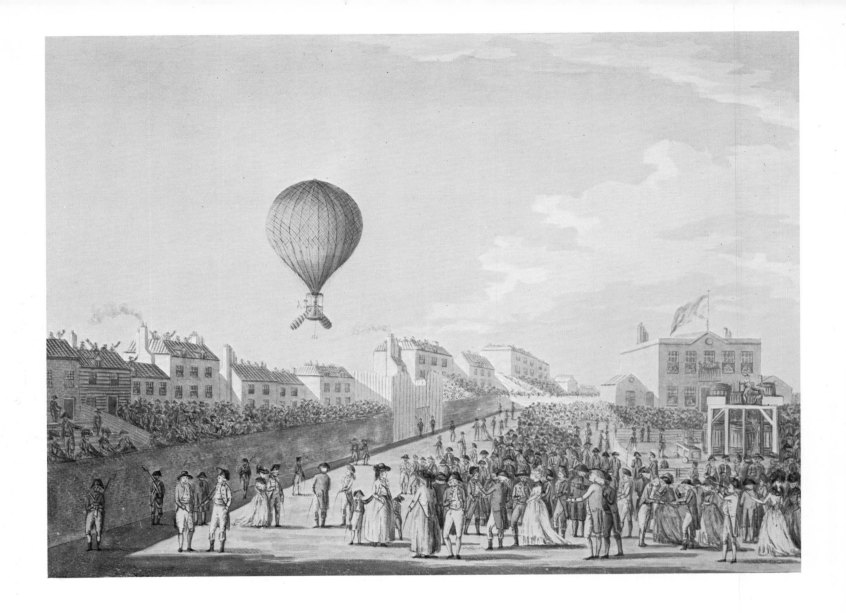

PLATE 2 John J. Brewer *Lunardi's Balloon Ascent, 15 September 1784* 1784

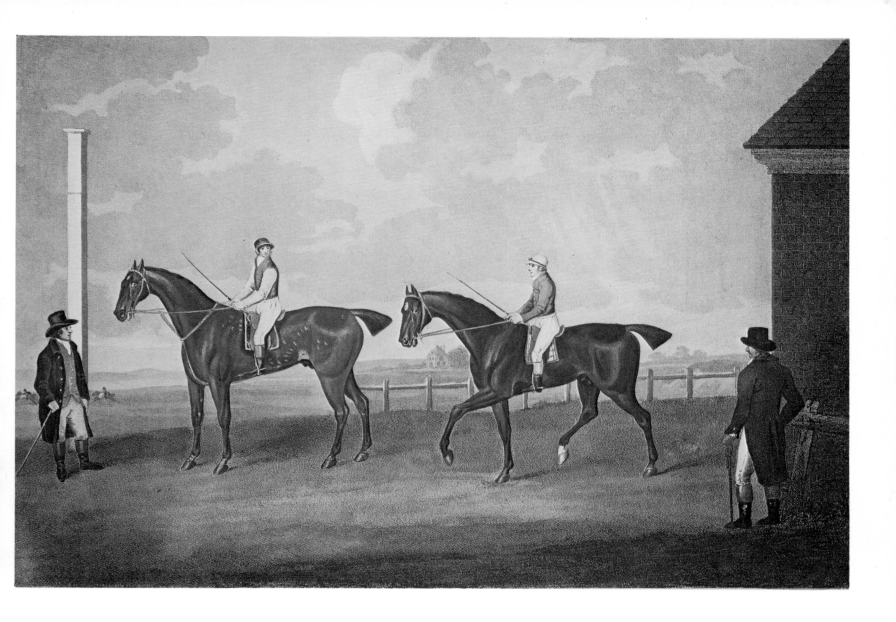

PLATE 3 John Nost Sartorius *'Hambletonian' preparing to start against 'Diamond' at Newmarket* 1800

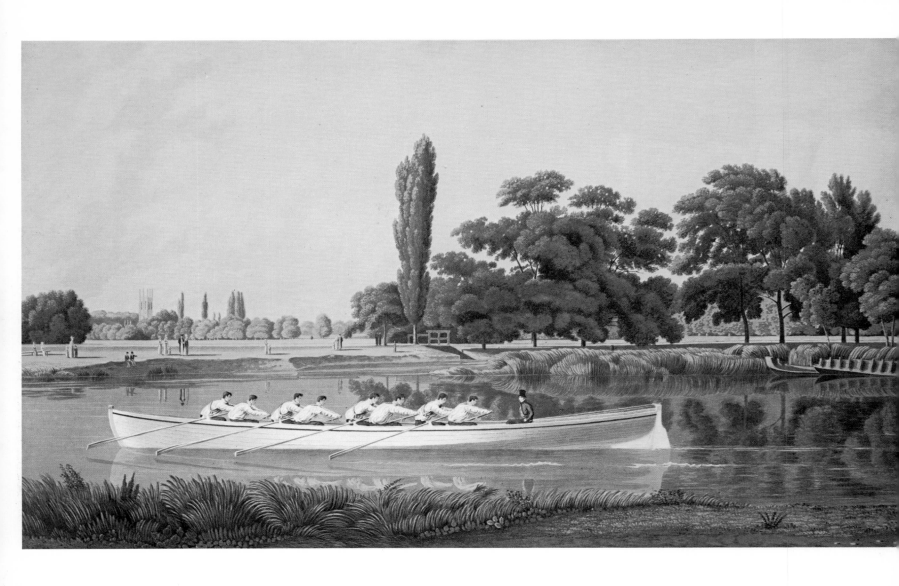

PLATE 4 Attributed to Robert Havell [1] *The First Cambridge University Crew* 1829/30

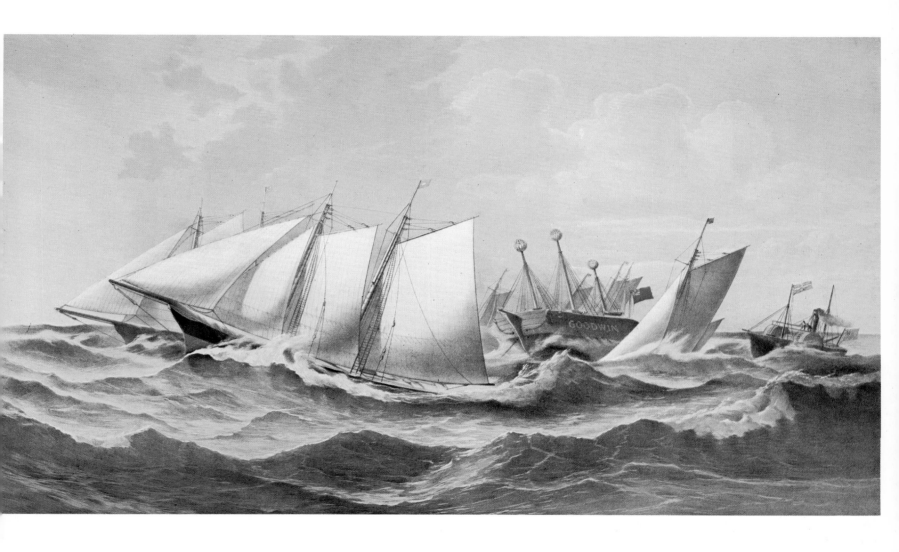

PLATE 5 Charles R. Rickett *Royal Thames Yacht Club – Ocean Match from Nore to Dover* 1874

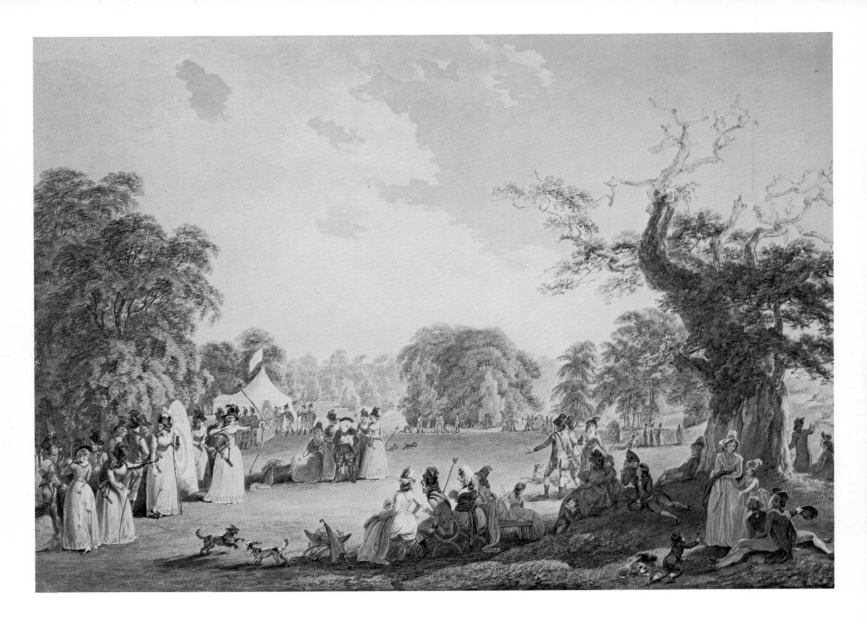

PLATE 6 John Emes and Robert Smirke *The Royal Society of British Archers in Gwersyllt Park* 1794

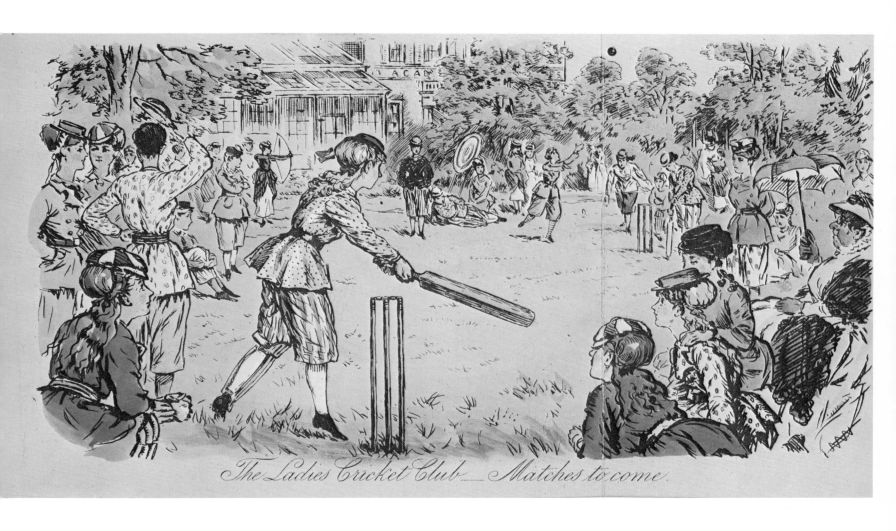

The Ladies Cricket Club — Matches to come.

PLATE 7 Charles Keene 'The Ladies Cricket Club – Matches to come' 1869

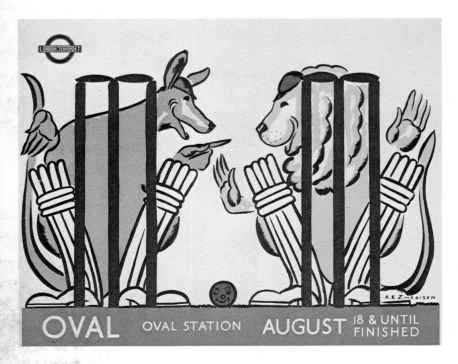

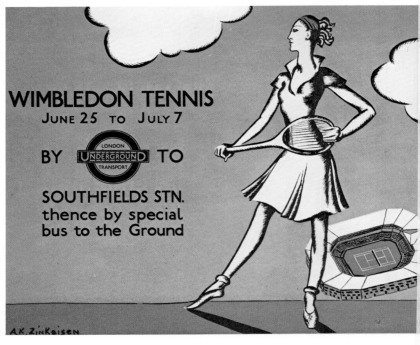

PLATE 8 Anna Zinkeisen *Oval Test Match c.* 1930

Anna Zinkeisen *Wimbledon Tennis c.* 1930